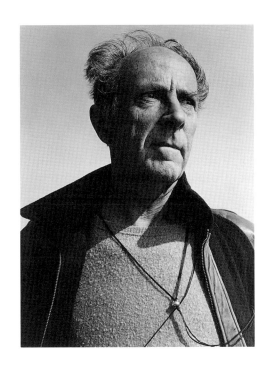

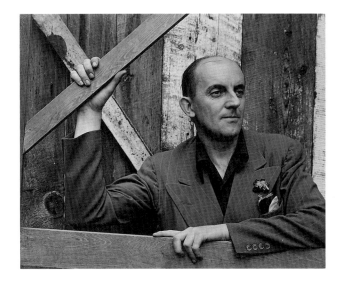

Ansel Adams

Edward Weston, 1945

Edward Weston

Ansel Adams, 1943

Through Their Own Eyes

The Personal Portfolios of Edward Weston and Ansel Adams

Introduction by
Richard Andrews

Essays by
Estelle Jussim
Diana Emery Hulick

Henry Art Gallery
University of Washington
Seattle

Exhibition itinerary

Henry Art Gallery
University of Washington
Seattle, Washington
June 12-August 11, 1991

Art Gallery of New South Wales
Sydney, Australia
January 25-March 8, 1992

Westpac Gallery, Theatres, Victorian Arts Centre
100 St. Kilda Road
Melbourne 3004 Australia
March 19-April 26, 1992

Hara Museum of Contemporary Art
Tokyo, Japan
June 6-August 30, 1992

Library of Congress
Cataloging-in- Publication Data

Andrews, Richard.

 Through their own eyes: the personal portfolios of Edward Weston and Ansel Adams/Richard Andrews, Estelle Jussim, Diana Hulick.
 p. cm.
 Exhibition schedule: Henry Art Gallery, University of Washington, Seattle, Washington, June 12-August 11, 1991.
 Includes bibliographical references.
 ISBN 0-935558-28-4
 1. Photography, Artistic—Exhibitions. 2. Weston, Edward, 1886-1958—Exhibitions. 3. Adams, Ansel, 1902—Exhibitions. 4. Weston, Edward, 1886-1958—Criticism and interpretation. 5. Adams, Ansel, 1902—Criticism and interpretation. I. Jussim, Estelle. II. Hulick, Diana Emery. III. Henry Art Gallery. IV. Title.

TR647.W44 1991 91-70042
779'.092—dc20 CIP

ISBN: 0-935558-28-4

Publication Coordinator: Tamara Moats
Editor: Nicholas H. Allison
Graphic Designer: Douglas Wadden

First published in the United States of America in 1991 by the Henry Gallery Association in conjunction with the exhibition *Through Their Own Eyes: The Personal Portfolios of Edward Weston and Ansel Adams*. Distributed by University of Washington Press.

The Henry Art Gallery is grateful to the Ansel Adams Publishing Rights Trust for permission to reproduce Mr. Adams's photographs. In accordance with their requirements, the majority of his work is printed in the 3 x 3¾ inch size.

Major support for this exhibition has come from The Capital Group, Inc., Los Angeles and the SAFECO Corporation. Additional support has come from the Seattle Arts Commission, The Boeing Company and Kidder, Peabody and Company.

Major support for presentation in Australia has come from Westpac Financial Services Group Limited, a wholly-owned subsidiary of Westpac Banking Corporation.

Partial support for the Japanese presentation of this exhibition has come from Baring Securities (Japan) Limited and the American Embassy in Japan.

Acknowledgments

Many individuals contributed to the organization of this exhibition and catalogue on the work of Edward Weston and Ansel Adams. We are particularly indebted to Robert Egelston, chairman of the board of The Capital Group, Inc., for his foresight in acquiring the Weston and Adams portfolios that are the essence of this project, and for his enthusiastic support. Robert S. Macfarlane, Jr., advisor to The Capital Group, Inc., and longtime admirer of Weston and Adams, was an early proponent of the exhibition and an important advisor throughout the project. We are especially appreciative of the registrarial assistance provided by Martha Williams of The Capital Group, Inc.

Chris Bruce, senior curator of the Henry Art Gallery, oversaw the development of the exhibition and drew upon the advice of Diana Emery Hulick, who served as guest curator for the exhibition. Dr. Hulick did extensive research on the lives and work of the two artists and reviewed the over 800 photographs in Weston's portfolio to prepare a selection for the exhibition. We are most grateful for her work on behalf of the project and for the additional research provided by Arizona State University graduate students Jeffrey Murphy, Melissa Guenther, and Gary Higgins. Much of this research was carried out at the Center for Creative Photography in Tucson, which contains the Edward Weston archives as well as extensive selections of both photographers' work. The Center was most cooperative in all respects and is a model research facility.

Support for the exhibition and catalogue was provided by The Capital Group, Inc., SAFECO Corporation, The Boeing Company, the Seattle Arts Commission, and Kidder Peabody and Company. Private support for the programs of the Gallery is raised by the Henry Gallery Association and, under the leadership of Board Chairman Walter Parsons and Association Director Fifi Caner, this patronage now provides well over half of our annual budget.

We are delighted that the exhibition is able to travel to Australia and Japan. We are appreciative of the efforts of Mr. Edmund Capon, director of the Art Gallery of New South Wales, Ms. Sandra Byron, curator of photography at the Art Gallery of New South Wales, and Mrs. Jacqueline Taylor, director of the Westpac Gallery, Victorian Arts Centre, to bring the exhibition there. We are particularly grateful for the financial support of Westpac Financial Services Group Limited of Westpac Banking Corporation in Australia, and the help of the Unit Trusts division of WFSG and its national marketing manager, Ian McGregor, as well as Madeleine Read, external and media relations manager. We would also like to thank Director Toshio Hara of the Hara Museum for his personal interest in the exhibition and his efforts to bring the work to Japanese audiences. Judith Connor Greer, assistant director of the Hara Museum, was an essential early supporter of the project and greatly assisted in solving the myriad problems that accompany an international tour.

In addition to her work as guest curator, Diana Hulick kindly prepared an extensive essay for this publication. We are also most grateful to Dr. Estelle Jussim for her excellent contribution, which provided new insights into the work of Weston and Adams. Tamara Moats, Henry Art Gallery curator of education, served as managing editor for this catalogue and oversaw the many editorial aspects with skill and care. The clear and elegant design of this catalogue is the product of Douglas Wadden, and we are most appreciative of his longstanding affiliation with the Henry Art Gallery. Our editor, Nick Allison, skillfully edited the manuscripts, and Rod Slemmons, curator of photography at the Seattle Art Museum, served as manuscript reader and provided insightful comments. We also much appreciate the work of Jennifer Reidel, who provided the editorial assistance necessary for a project of this scale with her customary care and efficiency.

All museum exhibitions require the concerted effort of an entire staff, and the Henry Art Gallery is blessed with an abundance of skilled professionals who all contributed greatly to this project. The University of Washington provides essential support for our operations, and we much appreciate the support of the College of Arts and Sciences under the guidance of Dean Joseph Norman and Associate Dean for the Arts Arthur Grossman. As a university art museum we derive many benefits from association with the School of Art and are particularly pleased to have had the excellent research and writing skills of art history graduate student Susan Kemp, our exhibition intern, to call on during the organization of this exhibition.

Richard Andrews
Director, Henry Art Gallery

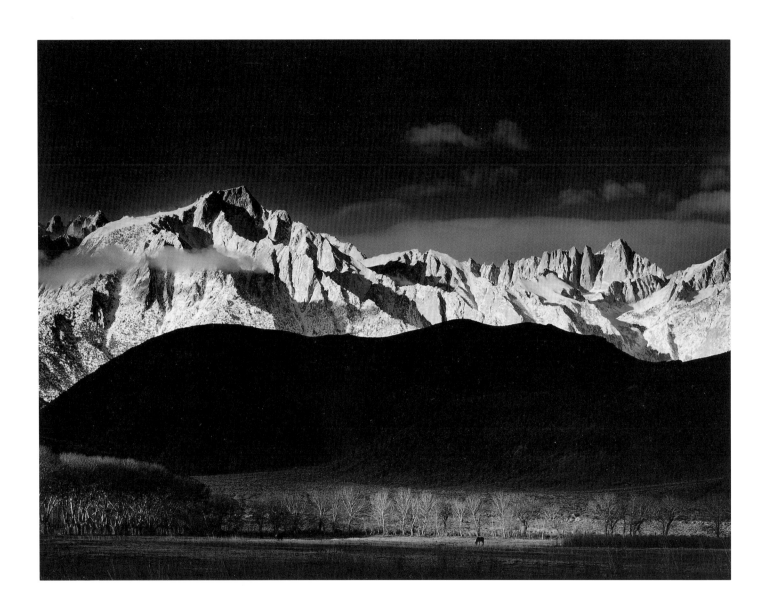

Ansel Adams

Winter Sunrise, the Sierra Nevada, from Lone Pine,
California, 1944

Table of Contents

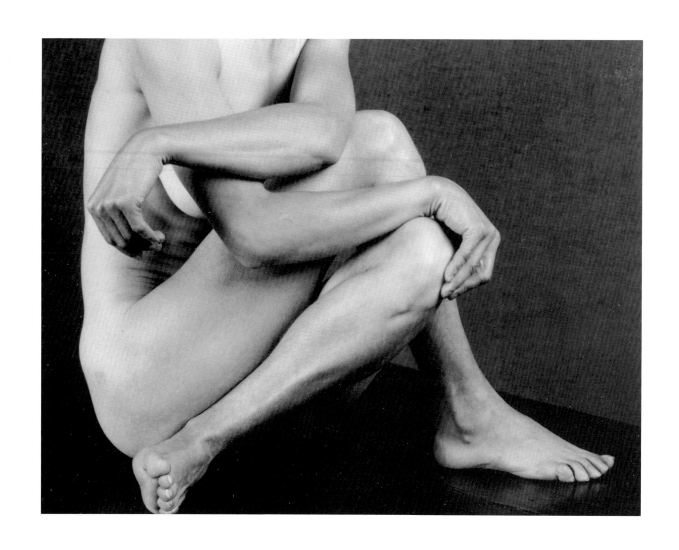

Edward Weston

Nude, 1934

Introduction

Photography as a creative expression, or what you will, must be seeing plus. Seeing alone would mean factual recording.

But photography is not at all seeing in the sense that the eyes see. …It is not 'seeing' literally, it is done with a reason, with creative imagination. …

Weston to Adams (January 28, 1932).

Edward Weston and Ansel Adams are among the most celebrated of twentieth-century American photographers. Their photography, writings, and unique personalities gave them unusual prominence during their lifetimes and were exceptionally influential in the development of photography as art. In fact, these two were extraordinarily conscious of their role as pioneers in an art form of fairly recent creation. From both streamed not only remarkable bodies of work but also journals and autobiographical writings which recorded every twist in the trails of their artistic development. As their work gained increasing attention during their careers, so too did the literary profiles produced by each. Particularly for younger photographers who sought role models or masters to study and emulate, Adams and Weston (along with such contemporaries as Alfred Stieglitz, Imogen Cunningham, and Paul Strand) represented heroic figures in the new art history.

Edward Weston and Ansel Adams were contemporaries (the latter sixteen years younger), primarily worked and lived in the same Northern California landscape, became friends early on in their careers, and were beneficial critics and supporters of each other's work. On the surface this kinship seems an unlikely development given the radical aesthetic differences between the two, their varied social backgrounds, and their differing lifestyles. Yet there were areas of commonality. The most significant was an absolute devotion to the camera as a means of describing, interpreting, and exploring the connection between man and the surrounding world; or, on a more abstract level, a commitment to delineating via photography the relationship between conscious sight and the ineffable truth of life. Each negative produced was a step further in this quest, and the writings of the two artists are a chronicle of the development of artistic con-

sciousness, paralleling and supporting the visual record. Perhaps the roots of their friendship can best be understood to stem from a sense of being kindred spirits working in the relative isolation of the art community of Northern California.

The works of Weston and Adams are well documented and have been much exhibited over the years. Yet rarely have comprehensive bodies of work by both men been shown together so that one might draw comparisons between the two. Such a juxtaposition, it seemed to us, would allow for consideration of the divergence in their artistic visions when they observe the same subject or locale, and of how the obvious differences in their styles bring forward questions about the development of photography, the influence of modernism, and the role of technology in limiting or expanding artistic vision.

The idea for this exhibition and publication emerged from such thoughts, and was further encouraged by the realization that these artists had yet another common aspect in their work separating them from other photographers: each, toward the end of his life, selected a body of negatives to be printed as a set that represented the distillation of his life's work. The fact that photography is an art of multiple "originals" printed over time not only extends the artist's control over individual images but makes possible a late-career visual autobiography. That both artists not only saw this as a possibility but made it a reality speaks to the drive—so evident in their writings—to lay out with utmost clarity their artistic goals and achievements, rather than leave it to others to define or describe.

Through Their Own Eyes: The Personal Portfolios of Edward Weston and Ansel Adams is an exhibition that brings together for the first time works contained in these self-selected retrospectives. In the case of Ansel Adams, his "museum set" consists of 75 images spanning a period of 47 years. Edward Weston drew his self-portrait more broadly, originally planning for the printing of approximately 1,000 negatives in his "project prints" but ultimately realizing the completion of roughly 830 with the assistance of his sons Brett and Cole. Looking at these selections, it is interesting to conjecture why certain images were left out while others were included. For example, Weston was well known for striking images of industrial plants taken during the 1920s, yet none made the final selection (perhaps he was reacting to criticism of these images as too imitative of the paintings of Charles Sheeler). Nor did his monumentalized Mexican toilet series make the cut, even though many images from his years in Mexico did. Adams's final selection is deliberately narrow, a reduction to those images that are quintessentially Adams, excluding those that might be closer to the work of others, or perhaps might deviate too far from the study of the natural landscape for which Adams is justifiably famous. But one does wonder about the exclusion of the Manzanar series, which documented the Japanese internment camps of World War II and meant enough to Adams that he gave the entire series to the Library of Congress to ensure that they would be remembered. Here, too, the artist may have been reacting to criticism, the charge that the series was a superficial examination of a dark moment in American history.

The vast difference in the number of images in the two portfolios posed a challenge in selecting works for the exhibition and catalogue. For the exhibition we selected 120 of Weston's images that reflect the breadth of work included in the "project prints" and maintain the basic categories seen in the portfolio; in Adams's case the entire set was included. In the catalogue we sought the same type of cross section for each photographer, balancing the well-known images with the less published, to give an impression of the scope of work seen in the portfolios while giving priority to images referenced in the contributors' essays.

The issues raised by the work of these key figures of twentieth-century photography are addressed in detail by Estelle Jussim and Diana Emery Hulick in their essays prepared for this catalogue. Dr. Jussim provides an overview of the careers of the photographers with an insightful consideration of their roles as influential modernists, and a comparative analysis of the sources of their inspiration. In her essay Dr. Hulick looks closely at the work of both men to compare their approaches to the act of making a photograph, the selection of subject matter, and the influence of advances in photographic technology on their work.

The two essays illuminate issues that are central to understanding Weston's and Adams's work. The reader will find that the comparative portraits of the artists reveal the extent of common ground, in artistic and philosophic terms, shared by the two friends, and a strong sense of their individual drives to extend the definition of photography as a fine art. That this is a continuing and substantive area of inquiry is highlighted by areas of divergence in the conclusions of Jussim and Hulick, particularly in their illuminating discussions of how these two artists influenced the development of twentieth-century photography, and how, in turn, modern technologies and ideas shaped the artists' work. The reader and exhibition visitor will find much food for thought and ample reason to look more closely at the familiar and unfamiliar images which delineate the careers of Edward Weston and Ansel Adams.

The need to define and control subject matter is evident in the work of both photographers. In this exhibition and catalogue we can see how this desire extended to the creation of idealized portfolios of their work, and in a sense how the life of the artist becomes the overarching work of art. The impulse toward careful autobiography is evident throughout the lives of both Edward Weston and Ansel Adams, and is consistent with a clearly established sense of artistic development. This development is linked to self-realization, and so the urge to summarize a life's work indicates a level of progress toward enlightenment. In the end, however, it is less important to second-guess the artists' selections and more instructive to use the photographs as a means to understand better the development of American photography from two of its acknowledged leaders. It is equally important to see these portfolios as companions to the written self-portraits left by both. Then the struggle to become, to be, an artist is made more clearly visible.

Richard Andrews
Director, Henry Art Gallery

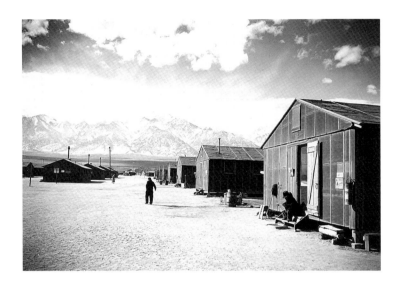

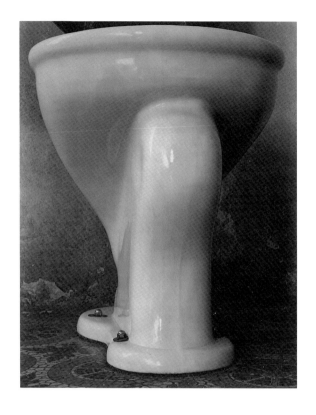

Ansel Adams

Manzanar Street, Winter, 1943
Courtesy of the Library of Congress

Edward Weston

Excusado, 1925
10 x 8 in (25.4 x 20.3 cm)
Center for Creative Photography

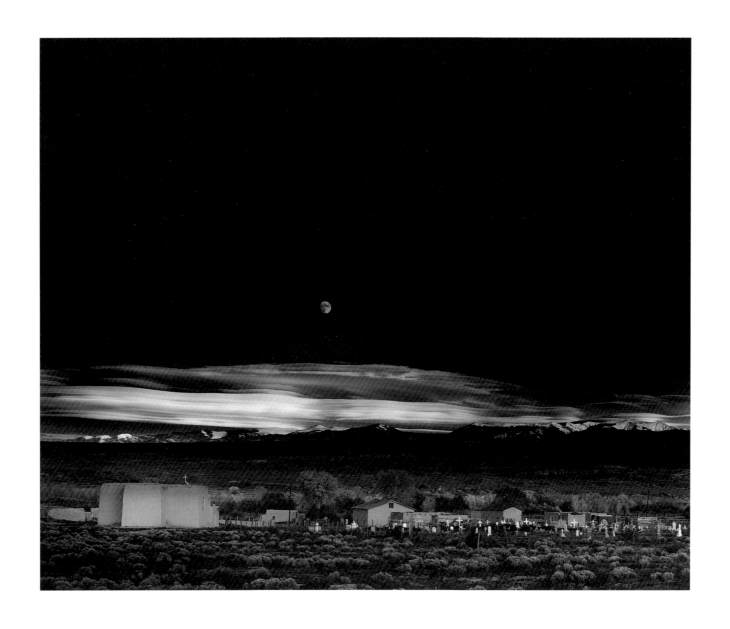

Ansel Adams

Moonrise, Hernandez, New Mexico, 1941

The Mind Sees, the Eyes Obey

Estelle Jussim

A photograph is not an accident, it is a concept.
Ansel Adams[1]

Estelle Jussim is an award-winning author of many books and essays on photography and the visual arts, including The Eternal Moment: Essays on the Photographic Image, Slave to Beauty: The Biography of F. Holland Day, *and* Stopping Time: The Photographs of Harold Edgerton. *She is a frequent critic for the* Boston Review, *and was awarded a Guggenheim Fellowship in 1982 for research on Alvin Langdon Coburn, the first modernist photographer. Dr. Jussim is a member of the graduate faculty at Simmons College, Boston, where she teaches courses in film, photography, history of the graphic arts, and mass media.*

What was it like to *be* Edward Weston or Ansel Adams? Does it help to know Weston was short, a vegetarian, penurious, the first photographer to be awarded a Guggenheim Fellowship? Is it useful to know that Adams was tall, the bringer of steaks and whiskey to parties with Weston, a fighter for conservation, and the first photographer to see his impish face on the cover of *Time* magazine? Weston was a modernist, after a youth admittedly misspent in Pictorialism; was Adams *not* a modernist? Does it make a difference that Adams made enlargements and Weston preferred the contact print? They were friends; what did they think of each other? What did they share? And what did they think about photography?

Photography makes claim to be a transparent medium through which we see the world. The dilemma is whether we are to admire the scene, the object, the person, or whether it is the print itself as artifact that should claim our attention. Perhaps we need to learn something of Weston's and Adams's approaches to the photographic medium. Otherwise, the overwhelming perfection of the pictures may seem superhuman, beyond the capacity of ordinary mortals to accomplish.

In his allegiance to the purist ideals of early modernism, Weston frequently reiterated a definite code of photographic behavior. On April 24, 1930, he set forth his methods almost in the form of a manifesto:

I start with no preconceived idea—
discovery excites me to focus—
then rediscovery though the lens—
final form of presentation seen on ground glass, the finished print previsioned complete in every detail of texture, movement, proportion, *before exposure*—
The shutter's release automatically and finally fixes my conception, allowing no after manipulation—
The ultimate end, the print, is but a duplication of all that I saw and felt through my camera.[2]

Ansel Adams also stressed that *previsualization* was the essence of his art. But as for "allowing no after manipulation," Adams's book *Examples: The Making of Forty Photographs* precisely detailed the methods he used, first in judging exposure according to his zone system, and then the intensive darkroom labors needed to bring forth each one of his technically perfect prints. (Beaumont Newhall believed that Adams's were the most beautiful prints ever made in the medium of photography.) Little wonder, then, that neophytes in photography are amazed to discover that they cannot simply walk out into nature and make the equal of an Adams picture. Previsualization was, indeed, primary among Adams's techniques, but it was the magic of the darkroom that produced a picture as mysterious, as dramatic, as *Moonrise over Hernandez*. A talented musician who had originally planned to be a concert pianist, Adams could declare that "the negative is the score; the print is the performance."[3]

In 1940, during a visit to Weston, Beaumont Newhall tried to make a "Weston" by exposure and composition; he failed. Newhall had taken Weston at his word, believing that Weston's exceptionally detailed and beautifully composed prints were the result of a superior eye and miraculous exposures. He was somewhat startled when Weston, with obvious amusement, took him into his darkroom to reveal hitherto undisclosed secrets of "dodging" and "burning in." This was hardly "no after manipulation."

These tricks of technique are the ordinary daily traffic with manipulation that photographers today take for granted. In Weston's mid-career, however, there was still a stigma attached to all varieties of manipulation used by the Pictorialists to mimic the effects of the graphic arts. In condemning the Pictorialists, the modernists inadvertently pronounced all manipulation anathema. Weston could be accused of willful misrepresentation when he claimed that "the shutter's release automatically and finally fixes my conception."

The fault perhaps lay with a misinterpretation of Alfred Stieglitz's insistence on "straight photography."[4] In the 1920s, when Weston was making a heroic effort to modernize his work, Stieglitz was still the major prophet of presumably unmanipulated photography. He was also the oracle of modernism. If Stieglitz exhibited your work, you were assured of a kind of celestial imprimatur that no one else could bestow. It was inevitable that Weston would seek Stieglitz's blessing when he visited New York in 1922. The elder statesman of photography spent some hours with him, haranguing him but also pointing out how to eliminate distracting details. Euphoric at having been granted an audience, Weston returned to California only to learn from a friend[5] that Stieglitz thought his prints "dead" and "theatrical." This judgment

so wounded Weston that he claimed, with considerable justice, that no "Easterner" could ever understand the intrinsic drama of Western scenery. He left for Mexico the following year and there dreamed that Stieglitz had died. Wishful thinking! He never gave up his anger, and once even described Stieglitz as "the Napoleon of art."[6]

Ansel Adams's encounters with Stieglitz —from 1933 to Stieglitz's death in 1946—were far more rewarding. In fact, Stieglitz applauded Adams, giving him the supreme accolade of a one-man show at An American Place in 1936. It was the first show Stieglitz had given to a young photographer since he exhibited Paul Strand in 1917. Adams wrote, "Stieglitz's doctrine of the equivalent as an explanation of creative photography opened the world for me. In showing a photograph, he implied 'Here is the equivalent of what I saw and felt. This is all I can ever say in words about photographs; they must stand or fall, as objects of beauty or communication, on the silent evidence of their equivalence.'"[7]

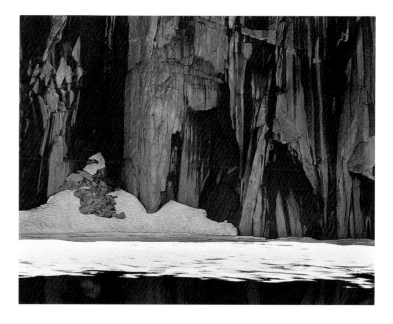

Ansel Adams

Frozen Lake and Cliffs, the Sierra Nevada, Sequoia National Park, California, 1932

Although Adams alternated between Stieglitz-worship and admitting the elder was both an enigma and a crank, it was his meeting with Paul Strand in Taos in 1930 that proved crucial. Strand precipitated his relinquishing his musical career to pursue photography full-time. Curiously enough, it was not Strand's stunning prints—Strand having none with him at the time—but his *negatives* that made an astonishing and permanent impact on Adams: "They were glorious negatives: full, luminous shadows and strong high values in which subtle passages of tone were preserved. The compositions were extraordinary, perfect, uncluttered edges and beautifully distributed shapes that he had carefully selected and interpreted as forms—simple, yet of great power."[8]

Strand became Adams's hero of technique, never his hero of subject. Though they were both members of the leftist-leaning Photo League in the 1930s and early 1940s, Adams resented pressures that demanded he make politico-social statements. "I think it is as important to bring to people the evidence of the beauty of the world of nature and of man as it is to give them a document of ugliness, squalor and despair," he wrote.[9] Weston completely agreed. After all, what they both wanted was to make abstract art, free of all political overtones. To create abstractions equal to those of modernist painters was one of Weston's strongest ambitions.

Even in the depths of the Great Depression, when one in four Americans was unemployed, Adams and Weston turned their backs on social problems to participate in the purist aesthetics of Group f/64 in 1932. Adams and the other group members—Willard Van Dyke, Edward Weston, Imogen Cunningham, Sonja Noskowiak—advocated modernist, sharp-focus ideals in which the medium per se demanded maximum attention. Despite his

reliance on the grandiloquent theater of landscape often associated with nineteenth-century giants like Eadweard Muybridge, Carleton Watkins, and Timothy O'Sullivan, Adams can only be regarded as a modernist. With Group f/64, he abandoned the velvet texture of the platinum print in favor of the high-contrast, sharply detailed gloss of gelatin-silver. In his *Examples,* Adams explains that the picture variously called *Frozen Lake and Cliffs* and *Kaweah Lake* represented his transition from the visual softness of Pictorialism to the contrast and detailed focus of Group f/64.

The aesthetic of the glossy print also revolutionized Weston's approach to photography. However, the almost tactile sharp focus was a characteristic not always admired. The curmudgeonly critic Clement Greenberg savaged Weston and other advocates of the new art photography in "The Camera's Glass Eye": "Merciless, crystalline clarity of detail and texture, combined with the anonymous or inanimate nature of the object photographed, produces a hard, mechanical effect….[Weston] has succumbed to…the unselective atmosphere of California—which differentiates between neither man nor beast nor tree and stone….An excess of detailed definition ends by making everything look as though it were made of the same substance."[10] But to be told that everything looked the same did not alarm Weston. It was the logical outcome of his strongly felt artistic ideology: "Clouds, torsos, shells, peppers, trees, rocks, smokestacks, are but interdependent, interrelated parts of a whole—which is life. Life rhythms, felt in no matter what, become symbols of the whole."[11] (See pages 19, and 38.)

Edward Weston

Sperm Whale's Teeth, 1931

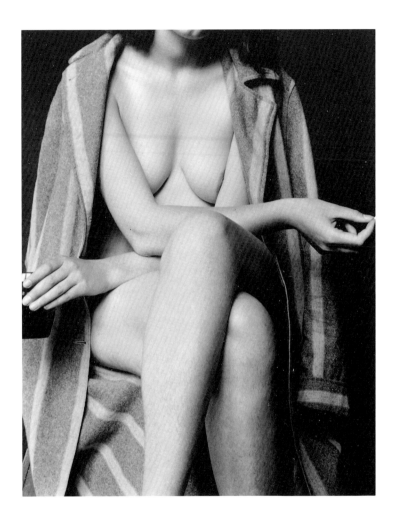

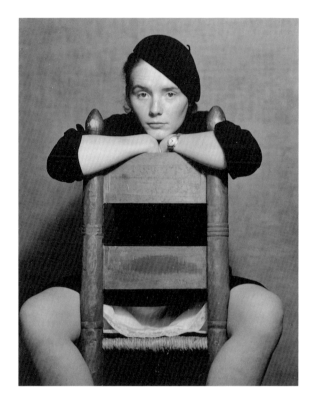

Edward Weston

Nude, 1934

Edward Weston

Charis Weston, 1935

Greenberg also complained that Weston's portraits were as "inanimate as his root or rock or sand forms: we get their coverings of skin or cloth but not their persons."[12] Harsh words indeed, yet others have similarly rejected Weston's nudes as exhibiting neither emotion nor sensuality. Greenberg charged that in pursuing such painstaking composition as we find in these images, Weston concentrated so much on design that he forgot to feel anything. The nudes are, in fact, as coldly exquisite as some of the odalisques of Ingres. Weston had many mistresses, even wondered in his Daybooks why he attracted so many women, and yet the nudes exude less passion than his evocative peppers. Not a single blemish, no suggestion of venality, mars the patinated skin of his future wife, Charis Wilson. Charis actually seems sexier with her clothes on. As for Weston's portraits lacking the personalities of the sitters, Greenberg must not have seen, or chose to ignore, the flamboyant portraits of Diego Rivera (see page 42) and his wife, Guadalupe.

Adams did not photograph the female nude. His interest lay elsewhere, in a spiritual identification with nature encouraged by reading and rereading the English mystic Edward Carpenter's poem *Toward Democracy*.[13] This book went with him on all his Sierra Club summer outings, and he frequently quoted a line from that epic: "the forests continue to flow over the land as cloud shadows."[14] In 1925, writing to his wife, Virginia Best, he announced that *Toward Democracy* had "established a real religion within me."[15] Carpenter's title was misleading, for the book was not about politics, but about transcendental ideas that "nothing in essence dies, and nothing in mortal form remains."[16] The material world constantly metamorphoses into the spiritual; and in *Frozen Lake and Cliffs*, with its rocks breaking from the cliff and falling into snow, which in turn is melting into water, the symbolism of ongoing metamorphosis in nature is unmistakable.

Adams believed that the ideal of wilderness he worshiped "competes with no religion; rather it suggests a new religion, the revelation of which is comprehension of the vast cosmos, and the ultimate purpose and validity of life."[17] In that perspective, Adams's vibrant landscapes lose their aura of melodrama and are revealed as profoundly mystical images created in the hope of guiding materialist humanity toward what he believed were higher goals.

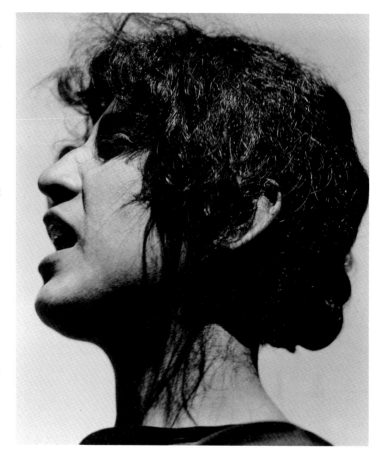

Edward Weston
Guadalupe Marín de Rivera, Mexico, 1924

Weston was in sympathy with cosmic revelations through the exploration of things in themselves. However, he admitted that he had been more "deeply moved by music, literature, sculpture, painting, than I have by photography."[18] Listening to Bach was deeply enriching, almost his greatest influence. Kandinskii, Brancusi, van Gogh, El Greco were his visual stimulants, while Spengler, Keyserling, Melville provided literary ideas. Of all these, he mentioned the sculptor Brancusi most often, boasting once that "with my camera I go direct to Brancusi's *source*. I find *ready to use*, select and isolate, what he has to *create*."[19] (See page 15.) John Szarkowski has remarked that although Weston and Adams inhabited the same California landscape, their images were essentially different: "The landscape in Weston's pictures is seen as sculpture: round, weighty, and fleshly sensuous. In comparison, Adams' pictures seem as dematerialized as the reflections on still water, or the shadows cast on morning mist: disembodied images concerned not with the corpus of things but with their transient aspect."[20]

Sculptural or not, what Weston said he was after was *"the greater mystery of things revealed more clearly than the eyes see"* (Weston's emphasis)[21] Symptomatic of his intense desire to see such mystery with his own eyes was his statement, "I would have a microscope, shall have one some day."[22] At various times, Weston insisted that he was not trying to express himself through photography, had no wish to impose his personality upon nature, but that he sought a "revelation or a piercing of the smoke-screen artificially cast over life by irrelevant, humanly limited exigencies,"[23] with the ultimate goal "an absolute, impersonal recognition."[24] It was that craving for impersonal recognition that gave so much of his work a cold sheen, and may help us to understand the lack of passion in his nudes. Often Weston claimed to hate science, yet paradoxically he pursued impersonality, the pseudo-objectivity of science that presumably matched the coolness of painterly abstraction.

Adams believed that Weston was one of the greatest artists of his time. He stated firmly, without equivocation, that Weston had "created the mother-forms and forces of nature; he has made these forms eloquent of the fundamental unity of the world. His work illuminates man's journey toward perfection of the spirit."[25] On the other hand, Adams recognized that Weston was far more limited in scope than he was, and far more static. He knew that Weston "equated gentle license with creativity; he could not imagine art without sex...."[26] Despite their differences on that score, and because of their many agreements, they remained good friends, supportive and generous.

"To photograph truthfully and effectively is to see beneath the surfaces and record the qualities of nature and humanity which live or are latent in all things.... Art must reach further than impression or self-revelation."[27] These are not, as might be supposed, the thoughts of Edward Weston. They are Adams, who, despite his admiration of Weston, continued to place Paul Strand at the highest level in his aesthetic pantheon.

Although Ansel Adams became famous for his efforts on behalf of saving the wilderness, he occasionally revealed a fundamental honesty about the realities of nature. In 1971, he wrote to his good friend and collaborator, Nancy Newhall, "Thoreau's 'In wildness is the Preservation of the World' is a strange introverted misinterpretation. The real wilderness is a hell of a place!"[28] But he had earlier postscripted a letter to Nancy with "I still like Nature. What a Momma!"[29] Adams had a lively sense of fun, and when a member of the audience at a museum lecture asked him a pompous question—"In the progress of your work have you ever been aware of achieving a new state of consciousness?"—Adams quickly replied, "I practice Zone not Zen."[30] Once he posed as a photographic Moses holding aloft tablets on which were inscribed his ten zones of exposure. It is hard to imagine Weston laughing at himself that way.

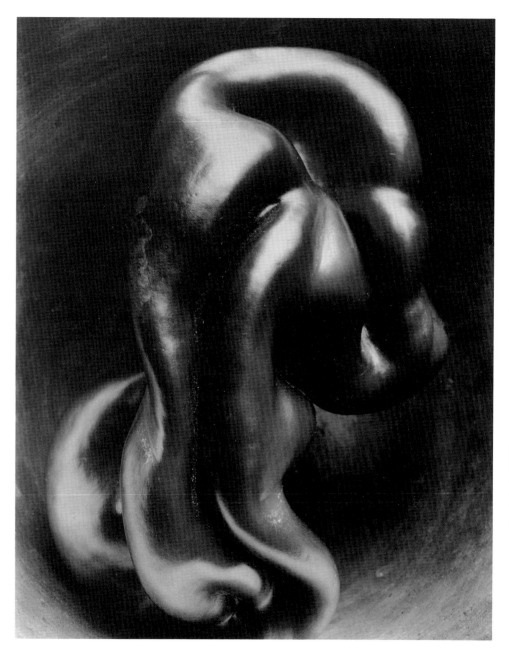

No painter or sculptor can be wholly abstract. We cannot imagine forms already existing in nature,— we know of nothing else. Take the extreme abstractions of Brancusi: They are all based upon natural forms. I have often been accused of imitating his work,—and I most assuredly admire, and may have been "inspired" by it,—which really means I have the same kind of (inner) eye, other-wise Rodin or Paul Manship might have influenced me! Actually, I have proved through photography that nature has all the "abstract" (simplified) forms, Brancusi or any other artist can imagine. With my camera I go direct to Brancusi's *source*. I find *ready to use,* select and isolate, what he has to "create." One might as well say that Brancusi imitates nature as to accuse me of imitating Brancusi, "negro sculpture," or what not,—just because I found these forms first hand.

But, after all, Ansel, I never try to limit myself to theories; I do not question right or wrong approach when I am interested or amazed—impelled to work. I do not fear logic, I dare to be irrational, or really never consider when I am not. This keeps me fluid, open to fresh impulse, free from formulae: and precisely because I have no formulae—the public who knows my work is often surprised; the critics, who all, or most of them, have their pet formulae are disturbed, and my friends distressed.

Weston to Adams (January 28, 1932).

Ansel did not care for my vegetables—least of all the halved ones. This is nothing new! I seem to be continually defending them! I can see the resemblance of some of them, especially the oft-maligned peppers, to modern sculpture—or Negro carving— but I certainly did not make them for this reason.

Weston, *Daybooks,* vol. 2 (February 1, 1932).

Edward Weston
Pepper, 1930

Weston made no secret of detesting cities and the urban masses. He was happiest living simply with Charis in his rude cabin at Carmel; there he could wander the shores of Point Lobos and seek the influence of the Pacific, much as Adams needed Yosemite and the High Sierra. Believing Adams to be squandering his energies, Weston urged his friend to relinquish his many activities on behalf of conservation, his teaching, his museum sponsorships, in order to concentrate on his photographic work. The inventor of the Polaroid instant-print system, Edwin Land, for whom Adams was serving as consultant, disagreed: "Weston lives in a shrine; you live in the world."[31]

Therein lay the most significant differences between these two titans of modernism. Although they both advocated previsualization, sharp focus, glossy gelatin-silver prints, subjects discovered rather than fabricated, although they could be accounted mystics and idealists, they parted company on almost all matters of worldly connection. Adams was a successful commercial photographer when he was not pursuing art for metaphysics' sake. Weston kept aloof, succumbing rarely to the blandishments of industry. Late in Weston's life, Kodak invited him to try their new color films. He obliged shortly before he was stricken with Parkinson's disease and photography was lost to him forever. Black and white, however, was the only medium for Ansel Adams, and for philosophical reasons: he believed that as photography "approaches the simulation of reality it withdraws from the aesthetic experience of reality."[32] His photographs were to be regarded as "ends in themselves, images of the endless moments of the world."[33] In that ideology, Ansel Adams and Edward Weston were in profound accord.

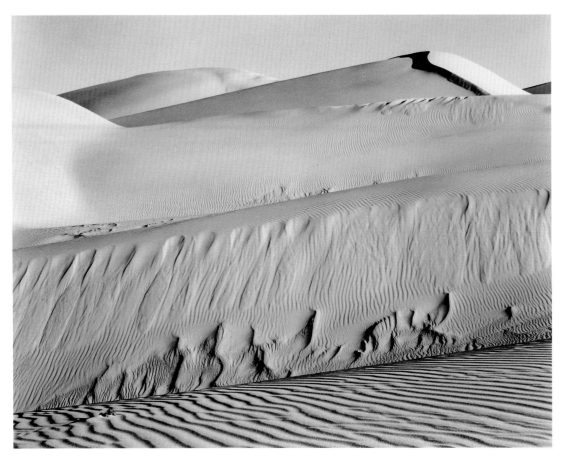

Edward Weston
Oceano, 1936

Notes

1. Quoted in Wallace Stegner, "Miraculous Instants of Light," in James Alinder, ed., *Ansel Adams 1902-1984* (Carmel, Calif.: Friends of Photography, c. 1984; *Untitled 27),* p. 52.

2. Quoted in Nancy Newhall, ed., *Edward Weston: The Flame of Recognition* (New York: Aperture, 1971), p. 86.

3. Quoted in Nancy Newhall, *From Adams to Stieglitz: Pioneers of Modern Photography* (New York: Aperture, 1989; Writers and Artists on Photography series), p. 11. In his book *Examples: The Making of Forty Photographs,* Adams explains that the negative, captured in extreme haste as the sun was setting, was difficult to print and he had to intensify it to increase contrast.

4. "Straight photography" was supposed to be antithetical to the Pictorialists' hand manipulations in processes like gum bichromate and bromoil. The term had two consequences: first, it satisfied the modernist emphasis on truth to the medium, and second, it demanded previsualizing the final print before exposure. However, even Stieglitz spent hours in the darkroom.

5. His friend was Consuela Kanaga. See Nancy Newhall, ed., *The Daybooks of Edward Weston, Vol. 2. California* (New York: Aperture, 1961), p. 234.

6. Ibid., p. 70.

7. *Ansel Adams: Yosemite and the Range of Light* (Boston: New York Graphic Society, special ed. prepared for The Museum of Modern Art, c. 1979), p. 12.

8. *Ansel Adams: An Autobiography,* with Mary Street Alinder (Boston: Little, Brown, A Bulfinch Press Book, 1990), p. 109.

9. Letter to Dorothea Lange, 1962. Quoted in *An Autobiography,* p. 269. Adams admired Lange, but it seems a strange proclamation to send to her, as she was devoted to portraying the human condition.

10. Clement Greenberg, "The Camera's Glass Eye" (1947), in Beaumont Newhall and Amy Conger, eds., *Edward Weston Omnibus: A Critical Anthology* (Salt Lake City: Gibbs Smith, Peregrine Smith Books, 1984), p. 87.

11. "Statement, 1930," in Peter C. Bunnell, ed., *Edward Weston on Photography* (Salt Lake City: Gibbs Smith, Peregrine Smith Books, 1983), p. 61. We can only wonder if Weston's notions of the oneness of life included the famous porcelain toilet base about which he said that it reminded him of the Victory of Samothrace. Hilton Kramer comments in his "Edward Weston's Privy and the Mexican Revolution" (in the *Omnibus,* p. 157): "This picture marks one of those turning points in the history of a medium—and all the more so in this case because the medium was one, and remains one, in which 'the subject' counts for so much. In exalting so humble and so unexpected a subject, Weston was asserting the primacy of the medium over the materials it recorded, and yet doing so without decrying or denigrating the necessity for a 'subject.'" The primacy of medium was at the apex of both Adams's and Weston's aesthetic ideologies.

12. Greenberg, "Camera's Glass Eye," p. 87.

13. Carpenter's epic poem was published in 1905. The book was brought to Adams's attention by his friend Cedric Wright, a musician/photographer. Weston was not quite the same sort of mystic. He was antiscience, and professed an interest in the theories of Charles Fort, the writer who attempted to explain UFOs and other oddities.

14. Quoted in Anne Hammond, "Ansel Adams: Natural Scene," in *Paul Strand and Ansel Adams: Native Land and Native Scene* (Tucson, Ariz.: Center for Creative Photography, *The Archive* 27, 1990), p. 17.

15. Ibid.

16. Ibid., p. 23.

17. Ibid., p. 22.

18. Nancy Newhall, ed., *Daybooks, Vol. 2. California,* p. 234.

19. Nancy Newhall, ed., *Flame of Recognition,* p. 44.

20. John Szarkowski, "Introduction," in *The Portfolios of Ansel Adams* (Boston: New York Graphic Society, 1981), viii.

21. Nancy Newhall, ed., *Flame of Recognition,* p. 42.

22. Ibid. See also Estelle Jussim, "Quintessences: Edward Weston's Search for Meaning," in *EW100* (New York: Aperture, 1988).

23. Nancy Newhall, ed., *Daybooks Vol. 2. California,* p. 241.

24. Ibid. In the same place, Weston also insisted that "through photography I would present the *significance of facts,* so they are transformed from things *seen* to things *known*" (Weston's emphasis).

25. Nancy Newhall, ed., *Flame of Recognition,* p. 100.

26. Adams, *Autobiography,* p. 240.

27. Ansel Adams, epigraph to *Portfolio One: Twelve Photographic Prints* (San Francisco: n.p., 1948).

28. Letter to Beaumont and Nancy Newhall, Sept. 13, 1971, in *Ansel Adams: Letters and Images 1916-1984,* ed. Mary Street Alinder and Andrea Gray Stillman (Boston: Little, Brown, A Bulfinch Book, 1990), p. 313.

29. Ibid., p. 204.

30. Adams, *Autobiography,* p. 235.

31. Quoted in Adams, *Autobiography,* p. 250.

32. Quoted in Wallace Stegner's foreword to *Ansel Adams: Images 1923-1974* (Boston: New York Graphic Society, 1981), p. 13.

33. Quoted in Nancy Newhall, *From Adams to Stieglitz,* p. 14.

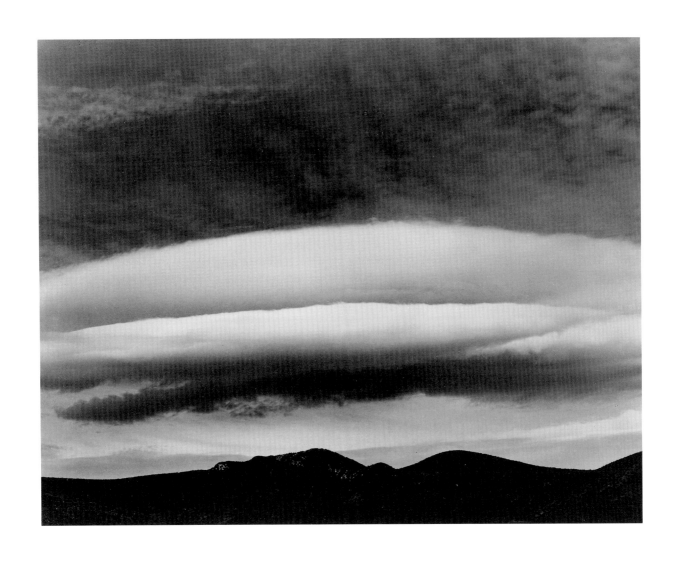

Edward Weston

Cloud over the Panamints, Death Valley, 1937
8 x 10 in (20.3 x 25.4 cm)
Center for Creative Photography

Continuity and Revolution: The Work of Ansel Adams and Edward Weston

Diana Emery Hulick

The photographs of Ansel Adams and Edward Weston have come to epitomize the so-called "straight" or unmanipulated photographic style of the 1930s through the 1950s. The work of both men was formally and technically brilliant, and each artist exhibited a fully realized personal aesthetic whose separate character defines one set of boundaries for American photography of the period.

Comparisons between the two are of necessity broadly drawn, but they serve to highlight the expressive range covered by these contemporaries, who managed to personify the tension between tradition and revolution while celebrating both nineteenth- and twentieth-century possibilities and limitations within the medium.

While both photographers introduce a note of heightened awareness of the reality they depict, Adams's work follows the conventions of nineteenth-century Western landscape photography and painting by describing a macrocosm that is complete unto itself, appears to exist without the photographer, and is baroque in its rich and skillful use of the camera's instrumentality. Weston's environments are less self-contained, and reflect the existence of the photographer through their acknowledgment both of human presence and of a world outside the frame.

One of Ansel Adams's major contributions to photography was explaining how to pre-visualize[1] the final print using a zone system to establish the print's tonal values.[2] These principles form the nucleus of his technical writings on photography and established his importance as a teacher. It was a way of seeing that mirrored the artist's own aesthetic, and established a standard by which we judge the modern silver print. While Edward Weston's later silver prints echo the scale of the nineteenth-century platinum print, which he used during the early 1920s, Adams's work highlights the qualities of new, twentieth-century materials.

Yet these photographers' technologies are in direct contrast to their iconologies; for Adams's innovative technical understanding serves a nineteenth-century vision of an unspoiled wilderness and a sense of unchanging traditional cultures, while Weston's nineteenth-century technique reveals a twentieth-century work with an iconography of dislocation, despoilment, and revolution. More specifically, these divergent attitudes are shown in Adams's and Weston's images of the natural world and in their photographs of, respectively, the Southwest and the Mexican revolution.

Each major technical development in the history of photography has influenced our understanding of the medium's potential. The daguerreotype gave people an enormously detailed vision of the world. The platinum print provided photographers like Weston with a long tonal range and floating, detailed shadows. The zone system, in its turn, created a new conception of how photographs ought to look. Codified by Adams in the 1930s, it has been a technical touchstone for photography students ever since. The system acquaints its practitioners with the relationship between exposure and development of both negative and print as a series of linked technical solutions, and is an admirable method for demonstrating photography as a decision-making process.

Diana Emery Hulick received her M.F.A. in photography from Ohio University, and in 1984 was awarded a Ph.D. in modern art history at Princeton University. She is assistant professor in art history at Arizona State University, where she teaches the history of photography. She served as guest curator for this exhibition.

Most importantly, the zone system represented a break with previous technical thinking about photography. In 1891, when the photographer Peter Henry Emerson published his pamphlet *The Death of Naturalistic Photography*, he stated that photography was a medium possessing insufficient artistic control. His analysis of scientific data on exposure and development collected by Hurter and Driffield led him to believe photography was too limited in its ability to vary tonality to be properly considered an art form. What Hurter and Driffield presented was evidence that photographic tonalities existed as an interconnected scale and were not infinitely variable. If a photographer changed the tonality of one part of the print by changing exposure time, the rest of the print would also change. Furthermore, these changes were limited in the negative and in the print to the equivalent of approximately two to three stops of exposure at both the highlight and the shadow end of the negative range. Because of these limitations, Emerson believed photography could not be an art form. With this thought in mind, critics, historians, and photographers spent the decades following his pronouncement expounding somewhat defensively on how photography could be an art form in spite of its limitations.

The zone system as propounded by Adams presents another point of view: Photography can be an art form *because* of its limitations. His recognition of Hurter and Driffield's contribution to this understanding appears on the dedication page of his book *The Print* (book three of his *Basic Photo* series). There he quotes these scientists as stating, "The photographer who combines scientific method with artistic skill is in the best possible position to do good work."[3] In his descriptions of the zone system, Adams asserted that limitations provide a point of focus which distinguishes one art from another, and that there were specific criteria against which prints could be measured. This touchstone became known as the "full-scale, full-substance" print.

Before the development of the zone system, standards of print quality could be based only on a comparison of one artist's work to that of another. For example, when Moholy-Nagy produced prints in the twenties that showed evidence of their processing, he was deviating from no single public standard. The artists and critics of that time had no touchstone beyond personal preference on which to base a technical judgment. The advent of a definition for the full-scale, full-substance print permits a more objective assessment of technical possibilities. This is not to suggest that there is no room for interpretation using the zone system, but rather that photographers could now identify and have a common understanding of such terms as the minimum threshold for shadow detail and the maximum threshold for highlight detail. Beginning with the publication of Ansel Adams's *Making a Photograph* by London Studio in 1935, they could also systematically educate themselves about the capacity of their own equipment and materials.

Ansel Adams

Lodgepole Pines, Lyell Fork of the Merced River, Yosemite National Park, California, 1921

The standard uses ten zones in which the film and paper are to accommodate any brightness range. Therefore the zone system is designed to create a certain level of abstraction, in that the subject must conform to a technical ideal. Furthermore, the silver print made in accordance with this system consists of sharply defined value contrasts emphasizing light as reflection. This characteristic often makes the work inaccessible on an emotional level, in a way that less immaculate printing by artists like Edward Weston is not. Inaccessibility is created because Adams's technique concentrates on revealing the relations of light as it is reflected off objects; hence, in contrast to Weston, there is often little sense of the subject's palpability or heaviness. All substances appear to have the same weight. In addition, and in contrast to the preceding Pictorialists who were popular from the 1890s to the mid-1920s, many of Adams's prints are in sharp focus throughout the entire picture plane. Although the zone system does not suggest this is a technical necessity, it is instructive to note that the system was popularized in the 1930s at the same time coated lenses became available. Coated lenses reduce internal flare created by light passing through the various components of the lens, which means that objects in front of the lens can be rendered with greater apparent sharpness. The transition from the soft focus of Pictorialism to the sharp, insistent focus of artists like Adams was accompanied by technological advances which made possible the clear separation of photographic tones.

The new hegemony of the "straight" or unmanipulated print, as espoused by both Adams and Weston as well as Group f/64, which they helped found in 1932, was also accompanied by a shift in geography. Pictorialism was essentially the product of photographic seeing as practiced in Europe and on the East Coast of the United States. Images of the Eastern landscape and of western Europe were the product of a humid climate, with dense vegetation and relatively short distances. These images tended to replicate what it was like to walk through this landscape and apprehend it emotionally. Steichen's image *Moonrise, Mamaroneck, New York, 1904*, produces a sense of being enclosed in the woods at dusk. Like Symbolist art, this piece is emotionally evocative in the manner of a dream. Conversely, the Western landscape is often apprehended through the organ of sight alone. Dry air, long distances, and raking sunlight make this an expansive landscape of definite form. Its early major photographers, such as Timothy O'Sullivan, were often members of survey parties who were seeing it for the first time when they recorded it in the last third of the nineteenth century.

A tradition of exploratory Western landscape photography was established in this manner. Rather than emphasizing a sense of personal and intimate involvement with the landscape as in the East, Western landscape photographs reveal themselves to be expository images which give the viewer visual access to newly recorded and rarely traversed land. Since the majority of these early images were made during surveys, they were also scientific in intent. The scientific basis of the zone system, coupled with the pristine quality of Ansel Adams's vision, make him an apt inheritor of this Western tradition. He writes, "The desert experience is primarily one of light, heroic sunlit desolation and sharp intense

shadows are the basic characteristics of the scene."[4] His images echo this sense of distance from the subject—we may have seen a given site before, but not heroicized in this way. Zone system controls enable Adams to literally will his interpretative vision into existence. His images become archetypes because they are structured creations born from the control of light. In this way Ansel Adams fictionalizes his documentary imagery by manipulating the representation of subject to conform to a technical ideal.

Western light is characterized by the visible gradients that it possesses. Although Adams photographed in a variety of lighting conditions, sharply graduated desert lighting would have presented him with the evidence he needed to visualize and codify the zone system. This codification represented part of his developing awareness of light throughout his career. In his book *Examples: The Making of Forty Photographs,* he writes consistently of light and angle of view as being his major technical problems. Repeated references are made to using separation of values to clarify form. The text also provides some insight into the chronological development of his understanding and awareness of how light functions. His circa 1921 image *Lodgepole Pines* was taken with a soft-focus lens. In describing this image, he comments on the "positive, dominant element" of Pictorialism as an "impression of light," its quality "not a matter of delineation of line or texture, but of luminosity: light emanating as a glow from the surfaces of the subjects."[5]

The wording of this description suggests that Adams saw a world that was created by light. Herein a conundrum is created: Adams's landscapes are exposed using the light of a given moment, and so are essentially ephemeral; yet, at the same time, his vision is so ideal as to be timeless. Furthermore, the natural world he photographs is an inherently mutable one whose essential fragility is underscored by the sharp detail with which it is rendered. Because they are about light striking the surface of objects, his images have a compressed sense of illusionistic space which he enhances through a careful siting and angling of the camera. This tension between the flatness of the picture plane and the illusion of depth in the landscape keeps the viewer at a visual and psychological distance. We can rarely imagine ourselves entering his landscapes. In certain cases, as in *Mount Williamson, the Sierra Nevada, from Manzanar, California, 1945,* we are figuratively denied access by the foreground boulders. The visual inaccessibility of Ansel Adams's landscapes may be specifically connected to his feeling for the American land and to his symbolic understanding of light in the Western landscape. He was an ardent conservationist, and his pictures tell us to look but not to touch. His landscapes are as inherently brittle and ephemeral as the light which reveals them.

These qualities are in direct contrast to the palpability and three-dimensionality of Weston's subjects. Even when photographing the Western landscape, Weston consistently assigns differing visual weights to different objects. Although the visual weight does not always correspond to the actual weight of the object in nature (clouds may appear heavier than the landscape below them, for example), it does correspond to the importance of the object within the picture as a whole. Light in Weston's work is also used to reveal textures so that we may apprehend the tactility of each object and the sensual relationships between them. This is light in the service of emotional, if not physical, accessibility.

Weston let the subject dictate the approach he would take and devised individual, ad hoc solutions, both during exposure and in printing. These solutions are not only concerned with the formal qualities of the subject; rather they are subordinated to its descriptive qualities, which are intended to reveal the thing itself. This required an apprehension of the subject's gestalt, an individuated sense of its materiality. Straw is rendered differently than ceramic, plant life differently than metal, the qualities of flesh differently from those of clouds, and so on. As a result, a broadly based emotional understanding of the object's significance in the life of the photographer is brought into play and inherently symbolic attributes emerge, to play one object off against another in his prints. This interplay is brought about through shifts in light, tonality, or focus.

Weston often used longer exposures than Adams did (particularly in his still lifes) and was less likely to use a filter to correct tonality or to eliminate chromatic aberration in his often less-than-perfect lenses.[6] Instead, he usually stopped down his lenses as much as possible, even using black paper with a hole in it in one case to increase the appearance of detail in the finished photograph.[7] Because of these optics, his equipment, and his printing, Weston saw the photograph as possessing "infinitely subtle gradations from black to white."[8] Until the late 1920s he contact-printed negatives using long-scale palladium or platinum paper, which was popular at the turn of the century.

Ansel Adams

Mount Williamson, the Sierra Nevada, from Manzanar, California, 1945

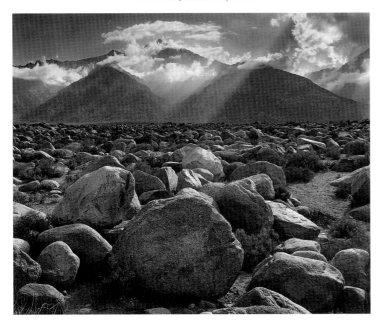

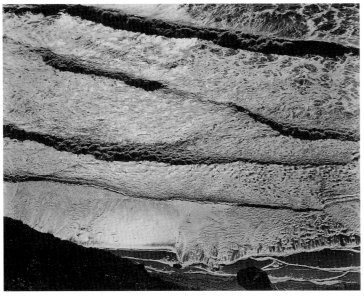

When he printed eight-by-ten-inch images from smaller negatives, he would have to make larger copy negatives since he had no enlarger.[9] This limited equipment was occasioned by straitened finances, but Weston made a virtue of necessity by believing that it was best to learn to see in terms of one lens, one film, and one paper, rather than acquiring a smattering of knowledge about a variety of processes. In this manner, he felt one could gain an intuitive relationship to the exposure of the photograph.[10]

The emphasis of intuition over planning, which was based on the exigencies of less elaborate and more unreliable equipment than that possessed by Adams, meant that Weston's approach to photography was dictated by responding to the needs of the moment rather than planning his technical controls in advance. Although both Adams and Weston attempted to previsualize the finished print on the ground glass of the camera, Weston had to work toward his visualizations, often overcoming repeated failures of craft, the solutions to which became part of his understanding of what it meant to be a photographer. He writes of "what can be done by repeated technical experiments," and his recording of his experiments and difficulties describes a more reflective nature than that of Adams, who had extensive physical resources at his command.[11] Since Adams had better lenses, he often used shorter exposure times. Since he was more interested in the control of gray-scale values, he frequently used red, yellow, and orange filters, which increased tonal separation and sharpened apparent focus.[12]

These technical variables contribute to the vast differences in "visual weight" that photographs by these two photographers possess. Compare *Mount Williamson, the Sierra Nevada, from Manzanar, California, 1945,* by Adams with *Cloud over the Panamints, Death Valley, 1937,* by

Weston (see page 22). In these images, Edward Weston's cloud appears to be heavier and more three-dimensional than Ansel Adams's rocks.

Adams's consistent concern with light is commonly mirrored in his titles. They often mention the time of day or the weather conditions under which an image was exposed. References to moonrises, sunrises, and clearing storms indicated the artist wanted the viewer to understand the specific technical challenges he faced. Published in 1983, *Examples: The Making of Forty Photographs* is a personal summation of stylistic development, which for Adams was ever-increasing technical control. Unlike Weston, he did not approach his subjects as images to be revealed, but as images he previsualized and willed to form. Later interpretations of the zone system by such artists as Minor White suggest the need for an internal dialogue as the photographer comes to conclusions about how he or she wishes to expose the subject.[13] It is apparent from reading Adams, however, that by using his technical orientation, he knew almost instantaneously how he wanted a photograph to look.

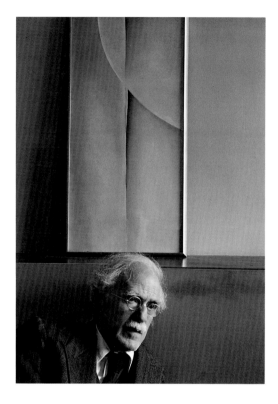

Ansel Adams

Alfred Stieglitz and Painting by Georgia O'Keeffe,
An American Place, New York City, 1944

His decision-making process was facilitated by his very consistent aesthetic. From the 1930s on, his work shows a marked use of strong value contrasts to separate forms. His use of the zone system meant he exposed for shadow detail while creating minimum-density negatives. This emphasis on minimum density enabled strong value contrasts to coexist without undue opacity in the print, and had the effect of increasing the print's surface transparency and hence its "visual lightness." Tonal separation occurred in the darkroom as well. Adams preferred to use waterbath development to increase the range of the negative rather than development by contraction. He felt this procedure to be superior, because it "holds the high values within printable range, but also strengthens the shadow area contrasts."[14] Maintaining these contrasts helped him preserve the quality of the shadow edge, a factor which he found to be important for rendering the subject's form.[15] Finally, in addition to using filters during exposure, Adams also sometimes used a final selenium toning to subtly enhance the tonal range and permanence of his prints.[16] These techniques are all designed to increase the tonal range and separation of the images while maintaining and at times increasing apparent acuity in detail.

Edward Weston was perhaps the last photographer to infuse his silver prints with the scale and tactility of platinum printing. Ansel Adams was the first photographer to codify new visual standards for the appearance of the silver print. The zone system therefore represents a scientific basis for a change in artistic values. As used by Adams, it suggests that his artistic development was increasing the ability to articulate an image through the specific control of light and value contrasts. Adams's work appears to undergo little visual change after his early work in the 1920s. Rather his artistic growth may be measured by the way

visual consistency is maintained throughout a variety of technical challenges centered around the control of existing light. This constancy introduces another element of timelessness, particularly when a body of his work is seen together in a book or an exhibit; for his photographs are not about visible process, but represent visible and decisive standards for the treatment of light in the silver print.

The use of a clearly defined technique to document an apparently unspoiled landscape and the lives of its inhabitants marks Adams at least in part as a conservative, for his image making preserved the objects photographed. His lifelong involvement with the Sierra Club, which began in 1919, is well known. Less well known is the fact that the Sierra Club Adams joined was a relatively small (fewer than two thousand members) but socially well-connected group whose attitudes were colored by a desire for continued personal access to the natural world.[17] At that time, their social standing, rather than today's ecological lobbying, was also a factor in their access to officials of the Department of the Interior and other governmental bodies, including, in the case of Adams himself, an acquaintance with several United States presidents.[18] Although Ansel Adams used these connections assiduously to promote conservation, his viewpoint also took into account the need for nuclear power as well as the experimental power of magnetic fusion.[19]

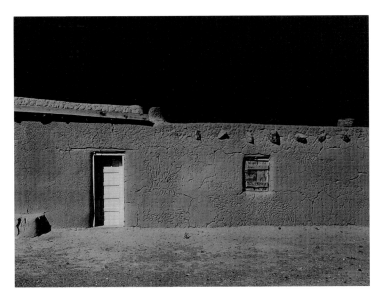

This conservative yet practical approach to the natural world is also seen in his architectural and sociological images of the Southwest. Adams, a Westerner, first learned about the importance of the negative and its printing when he met Paul Strand in 1930 at Taos Pueblo, which they both photographed, as did Weston. Both Weston and Adams contributed several images to Mabel Dodge Luhan's 1935 book *Winter in Taos.* For many years, Adams traveled throughout the Southwest, photographing pueblos, missions, and Hispanic towns. In context, many of these images appear to be attempts at cultural conservation and parallel his conservation of the natural landscape.

Around 1930 he began to photograph Spanish villages in the mountains of New Mexico. His images included those documenting the Penitente culture, a fundamentalist offshoot of Catholicism whose rituals center around the passion of Christ. This semisecret society is represented in Adams's work by details such as crosses and shrines and most eloquently by such later prints as his *Penitente Morada, Coyote, New Mexico,* c. 1950, which shows a shuttered window and closed door in a thick adobe wall. This symbolic and actual denial of access bears witness to the secret nature of much Penitente ritual, as well as to Adams's ability to convey cultural meaning through the telling detail. The roughness of the adobe wall, coupled with the rough-hewn qualities of the vigas or ceiling beams, convey vernacular construction and devout poverty, whose creation appears to be one with the earth from which it rises.

A more complex, if distanced, appreciation of Hispanic culture can be found in Adams's *Moonrise, Hernandez, New Mexico* of 1941 (see page 12). It was taken on Halloween, the day before All Souls' Day, known in Mexico and the American Southwest as the Day of the Dead. The highlighted graveyard in the foreground is not simply a formal element, but presages the Hispanic celebration to come. The image as a whole becomes a metaphor for the bridges between the world of the living and the world of the spirit.

Weston's major work involving Hispanic culture was done in Mexico from 1923 to 1926. Although Weston was himself apolitical, he entered the country in the midst of a revolution. The trip appears to have been an emblem of the freedom he would choose from bourgeois concerns, and stimulated a burst of development in his work. The Mexican environment in which he found himself helped strengthen his conviction that art and life were inseparable. With the help of Tina Modotti—photographer, revolutionary, and his lover—he gained access to the Mexican avant-garde and their revolutionary art and activities. He shared art and art talk with such artists as the painter Clemente Orozco and Diego Rivera, who championed native culture as opposed to imported European and North American cultures.[20] Both Modotti and Rivera believed in the integration of art and life and found the Mexican revolution to be a suitable subject for their work as well as a way to explore new ways of seeing.[21]

Ansel Adams

Penitente Morada, Coyote, New Mexico, c. 1950

In Edward's photographs of even his most static subjects I sense the immediacy of his perception and his highly developed aesthetic response.

Adams, *Examples: The Making of Forty Photographs* (1983).

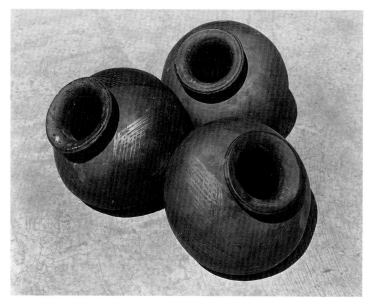

Edward Weston

Tres Ollas de Oaxaca, 1926
8 x 10 in (20.3 x 25.4 cm)
Center for Creative Photography

In 1926, Weston photographed folk murals on the facades of *pulquerías* to illustrate an article by Rivera for *Mexican Folkways Magazine*.[22] Two years earlier, he had begun to photograph *juguetes* or toys while he waited in his studio for portrait customers. He collected these at street markets, and they formed the basis for his first still lifes. Not only did he learn about these objects by photographing them, but his experimentation with their arrangement and with figure and ground relationships apparently contributed to the formal balance and simple immediacy of his later vegetable still lifes.[23]

His exposure to traditional Mexican art was even broader than this. Weston and Modotti traveled throughout Mexico making pictures of folk art, masks, *retablos*, architecture, and museum pieces for Anita Brenner's book *Idols Behind Altars*, published in 1929. Although commissioned to make these photographs, Weston was not indifferent to his subjects. While working for Brenner, he acquired some "gorgeous toys";[24] in the same Oaxaca market he found some pots to photograph whose blackness denied space and whose classic round shapes denied historical time.[25]

At the same time that Weston became fascinated and involved with Mexican folk art, he, like his revolutionary friends, was attempting to find new ways of expressing the beauty of contemporary life. While he was not a member of the "Estridentistas," or strident ones, as was Diego Rivera, like them he was attracted to the beauty of the machine and the machine-made object. Two journals connected with this movement of the Mexican avant-garde, *Irradiador* (Radiator) and *Forma* (Form), published his pictures in 1922 and 1928 respectively. The first of his published images was a 1922 rendition of the Armco Steel plant in Ohio. Although the image might be iconographically and ironically taken to represent the might that American industry imposed on the Mexican people, its very reproduction on the journal's cover suggests that the anonymous-looking image of a steel plant was instead linked to the Estridentistas' wish to participate in the international constructivist movement of the period by glorifying imagery of the machine.[26] The second image, a full-page reproduction of a toilet from a series of this fixture photographed by Weston in 1925 (see page 11), presents us with connotations that Weston himself considered important for a variety of reasons. The first is that, in choosing this subject matter, the greatest challenge was to enable the viewer to concentrate on the formal qualities of the object and on the factual qualities of its existence.[27] Yet we can also see his toilet series as a way of recording the daily reality of a Mexico impoverished by history and by revolution. Like the *juguetes* and Mexican art that he photographed and collected, Weston's toilets become a symbol of a different lifestyle. For the first time in his life, Weston had entered a foreign culture where common objects had a different value than in his own. This personal dislocation was seminal, for it permitted him to focus on the quotidian with fresh eyes, creat-

ing the basis for his mature style. Although he was apparently politically uninvolved in the Mexican revolution or its aims, he did partake of that renewed sense of visual freshness that the revolution offered.

However, the line between politics and art was far from clear. Weston's picture of the Mexican politician Galvan shooting was used as a political poster when Galvan ran for office. The portraits of Guadalupe de Rivera and Tina Modotti declaiming with uplifted head present a tension between the portrait of the individual and a symbolic act that is a metaphor for individual freedom. Similarly, the *pulquerías* that Weston photographed are bars for peasants and the working class, whose aims the revolution supported and whose lives are also reflected in the images Weston made of simple dwellings or of laundry drying in neighborhood courtyards. Perhaps even the dead man he photographed in Death Valley was a resonant subject in part because of his experience with the omnipresence of sudden death and dying during his Mexican years.[28]

When Weston depicted landscape, it was often a desert with no sign of current human life, although signs of former habitation were often present. These images are exemplified by photographs in Death Valley which contained abandoned mining sites. His formally beautiful prints show an incomplete, inhospitable, and uprooted nature, as opposed to Adams's pristine macrocosm. This affinity for a despoiled nature, like his affinity for the still life which began with the *juguetes*, may be the result of his exposure to the stark aridity of the Mexican landscape. The Mexican desert is closer in its bleakness to Death Valley than it is to the rest of the Southwest United States. Then, too, Mexico is a land that has a long history of permanent human settlements, whose gentle decaying picturesqueness Weston found cloying and sought to convey in photographs that were immediate and visually exciting. This early fascination with ruins reemerges in such images as his print of Leadfield, one of many abandoned sites whose architecture is rendered layered and transparent through ruin. In a similar manner, the murals decorating *pulquerías* presage Weston's later trompe l'oeil images of Hollywood sets, where reality and illusion appear to be one and the same (see page 31). This painted world is a simulacrum of which the photograph makes an image. Issues of depth and focus disappear; detail is determined by the painted surface, which, because it is a film set, was made to look real when photographed.

Weston's documentary style is permeated with an understanding that he must construct an individual relationship to each subject and that this relationship is arbitrary, artificial, and momentary. Thus, in his renditions of Hollywood sets, the painter's eye and the photographer's eye both journey toward one end, for the quintessence of such imagery is the illusion of reality as produced by the camera.

In Ansel Adams we find a photographer whose experimentation was technical rather than oriented toward subject matter and its individuated treatment. He is primarily concerned with preserving a nineteenth-century vision of an uninhabited, unspoiled natural world, while his images of people and their culture represent a variety of traditional Western values, couched in the twentieth-century language of the full-scale, full-substance silver print. In contrast, Weston often adopted the softer tonality exemplified by the nineteenth-century platinum print, and like his technical predecessors, experimented and worked toward solutions. His imagery, however, which ranged from aggressively sensual nudes and desolate landscapes to images of contemporary life, expresses a twentieth-century understanding of the shifting relationships between humans, their culture, and the natural world.

Dr. Hulick wishes to acknowledge the extensive research on this exhibit performed by Melissa Guenther and Gary Higgins, graduate students at Arizona State University. They worked tirelessly and thoroughly to answer the questions prepared for them while pursuing their own interests in Adams and Weston.

Edward Weston
Leadfield, 1939

Notes

1. *Previsualization* is a term popularized by both Ansel Adams and Minor White. It describes the ability of a practitioner of the zone system to see in the mind's eye how the final print will look while the exposure is first being made. Photographers also use the term more loosely to describe the ability to visualize the final print during exposure, regardless of the technique used.

2. James Danziger and Barnaby Conrad III, *Interviews with Master Photographers*, (New York: Paddington, 1977) p. 163. In an interview with Brett Weston, Edward's son, Brett tells the authors that Adams was not actually responsible for developing the zone system, suggesting rather that he codified and popularized it.

3. Hurter and Driffield, *Photominiature*, No. 56, 1903.

4. Ansel Adams, *Examples: The Making of Forty Photographs* (Boston: Little, Brown and Co., 1983), p. 57.

5. Ansel Adams, *Natural Light Photography* (Hastings on Hudson, N.Y.: Morgan and Morgan, 1971), p. v.

6. Gary Higgins, *Research Notes*, June-Aug. 1990. Higgins, a graduate student in photography at Arizona State University, has done considerable research on Edward Weston's lenses. In the main, it can be stated that Weston used lenses of reasonable quality by contemporary standards, but that they often lacked certain corrections, or were to some extent soft in focus, which meant stopping down as much as possible. Weston did use K (yellow and orange) filters to darken skies, but used these far less frequently in his work than did Adams.

7. Edward Weston, *Daybooks Vol. I*, Mexico, ed. Nancy Newhall (Rochester, N.Y.: George Eastman House, 1961), Dec. 21, p. 64.

8. Nathan Lyons, ed., *Photographers on Photography* (Englewood Cliffs, N.J.: Prentice Hall, 1966): "Seeing Photographically," by Edward Weston, reprinted from the *Complete Photographer*, Vol. 9, No. 49, p. 160.

9. Beaumont Newhall, *Supreme Instants: The Photography of Edward Weston* (Boston: Little, Brown and Co., 1986), p. 24.

10. Lyons, p. 162.

11. Weston, *Daybooks Vol. I*, p. 94.

12. Gary Higgins, *Research Notes*, June-July 1990: "Ansel Adams had a full set of seven Zeiss Protar lenses with interchangeable elements, and frequently used filters, especially yellow orange and red."

13. Minor White, *Zone System Manual* (Hastings on Hudson, N.Y.: Morgan and Morgan, 1971), p. 99.

14. Adams, *Examples: The Making of Forty Photographs,* p. 68.

15. Adams, *Natural Light Photography*, p. 6.

16. Adams, *Examples: The Making of Forty Photographs*, pp. 23-24.

17. David Brower, ed., *The Sierra Club: A Handbook* (San Francisco: Sierra Club, 1960), p. 93.
 Judging from the graphs provided, the Sierra Club had approximately 1,750 members when Adams joined in 1919. By 1960, the membership had reached 15,000. By 1985, membership was over 400,000 with more than 50 regional chapters.

18. Ibid., p. 5. Some of the club's prominent original members included George Perkins, United States senator, David Starr Jordan, president of Stanford University, and William Denman, senior judge of the United States Court of Appeals.
Ansel Adams, *An Autobiography* (Boston: Little, Brown and Co., 1985), pp. 346-50. Ford, Carter, and Reagan all knew Ansel Adams.

19. Adams, *An Autobiography*, pp. 153, 350.

20. Amy Conger, *Edward Weston in Mexico, 1923-1926* (Albuquerque: University of New Mexico Press, 1983), p. 20.

21. Ibid., pp. 17-19.

22. Ibid., p. 44.

23. Ben Maddow, *Edward Weston: Fifty Years* (Millerton, N.Y.: Aperture, 1973), p. 58.

24. Conger, pp. 51-54.

25. Ibid., p. 44.

26. Ibid., pp. 7-18.

27. Lyons, p. 155.

28. The Mexican photographer Manuel Alvarez Bravo exhibits a similar interest in subjects that might be related to revolutionary and traditional Mexican themes. *Pulquerías*, the landscape, bandaged nudes, and victims of violence are some of his subjects.

The physical environment of the California coast has left an impressive mark on Edward Weston. In the whirl and social vortices of the huge centers of civilization, it is easy to forget the simplicities of stone and growing things and the hard beauty of the implements of human relations with the primal forces. I do not mean to imply that Weston is inclined toward primitivism, but that he is on the frontier of a more subtle naturalistic order of life. While I doubt that he rationalizes his position—a deficiency that may have its advantages—he certainly is aware of the essential modernity of his medium.

Adams, *Creative Art*, no. 12 (May, 1933).

In the five years since Edward Weston passed away in Carmel, California, he remains in memory as a man of great spirit, integrity and power. To me he was a profound artist and a friend in the deepest sense of the word. Living, as I do now, within a mile of his last home, sensing the same scents of the sea and the pine forests, the grayness of the same fogs, the glory of the same triumphal storms, and the ageless presence of the Point Lobos stone, I find it very difficult to realize he is no longer with us in actuality.

Edward understood thoughts and concepts which dwell on simple mystical levels. His own work—direct and honest as it is—leaped from a deep intuition and belief in forces beyond the apparent and the factual.

While I never "worked" with Edward in the usual sense of the term, we were on many trips together—Yosemite, to the Sierra Nevada, to the Owens Valley. We were always aware of each other, but never "associated" in the limited sense of the word. We were joined in a common enterprise with Group f/64 in the early 1930s, and I worked closely with Edward and Dody in the production of *My Camera on Point Lobos.* It is difficult to tell others, especially through the printed word, what a profoundly important experience it was to know Edward as a man and an artist.

Edward was aware of the loneliness of the artist, especially of the artist in photography, but he accomplished more than anyone, with the possible exception of Alfred Stieglitz, to elevate photography to the status of a fine-art expression.

Adams, "Edward Weston," *Infinity*, no. 13 (February, 1964).

It is a pleasure to observe in Weston's work the lack of affectation in his use of simple, almost frugal, materials.

Adams, *The Fortnightly*, no. 1 (Dec. 18, 1931).

Ansel does not agree with me in hanging old "historical" work. (Only the best you have ever done, only examples of the photography you believe in should be shown.) Well then I say why a retrospective at all? I think a presentation of one's growth is of interest and importance—even early corn.

Weston to Nancy Newhall (August, 1945).

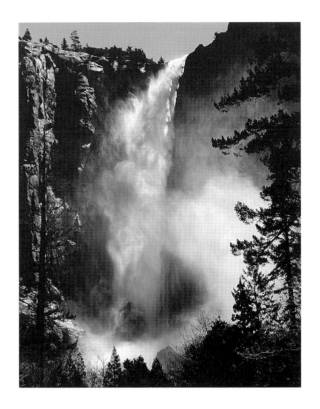

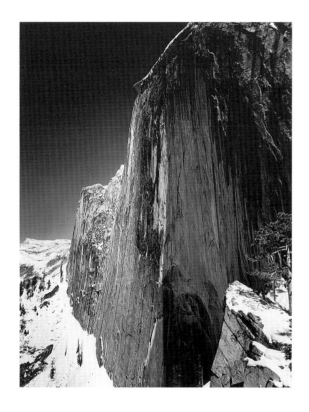

Ansel Adams

*Bridal Veil Fall, Yosemite National Park, California,
c. 1927*

Ansel Adams

*Monolith, the Face of Half Dome, Yosemite National
Park, California, 1927*

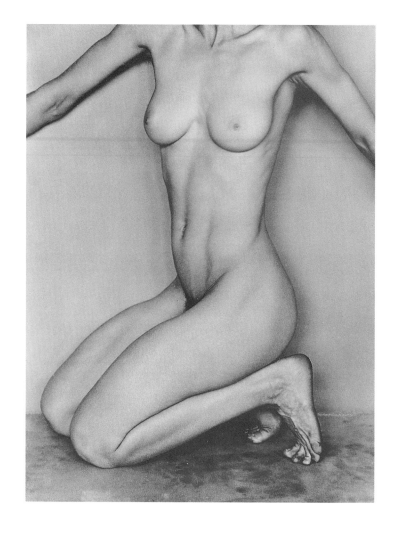

Edward Weston

Nude, 1934

Edward Weston

Nude, 1927

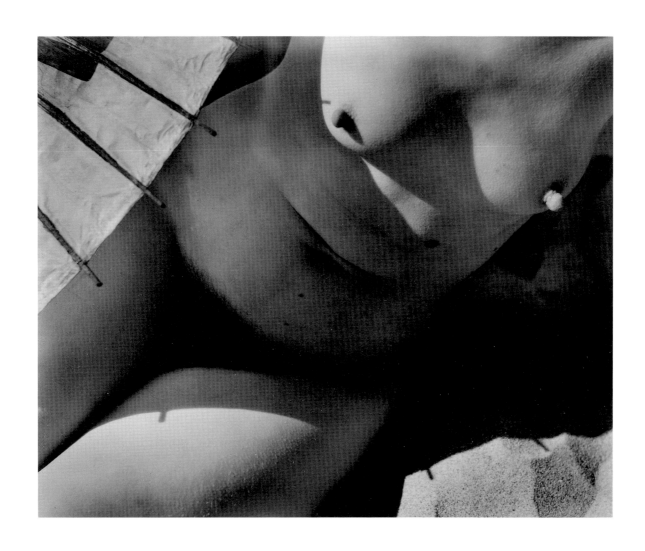

Edward Weston

Nude, 1923

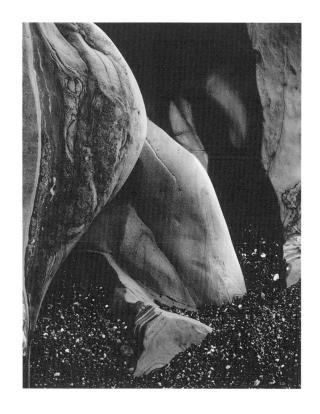

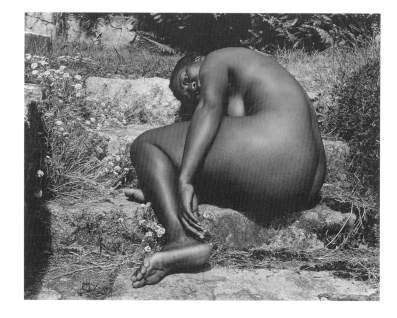

Edward Weston

Point Lobos, 1930

Edward Weston

Nude, 1939

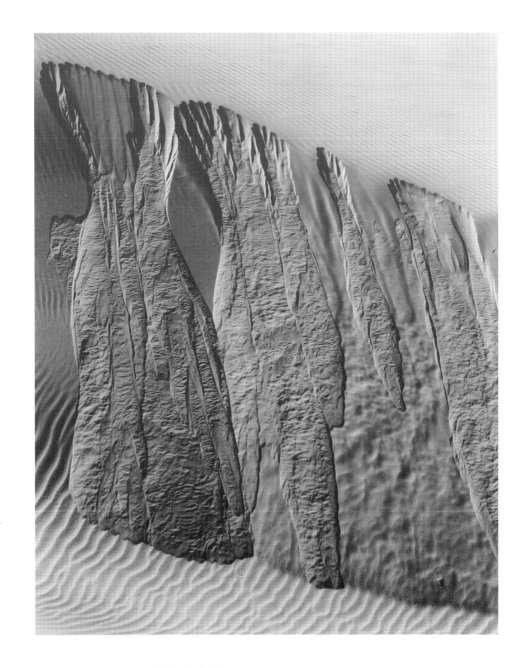

Edward Weston

Sand Erosion, Oceano, 1934

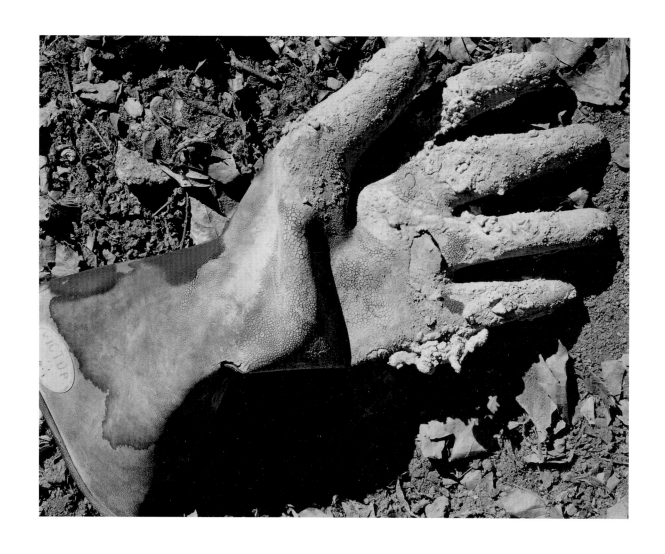

Edward Weston

Cement Worker's Glove, 1936

Edward Weston

Burned Car, Mojave Desert, 1937

Ansel Adams

Grass and Pool, the Sierra Nevada, California, 1935

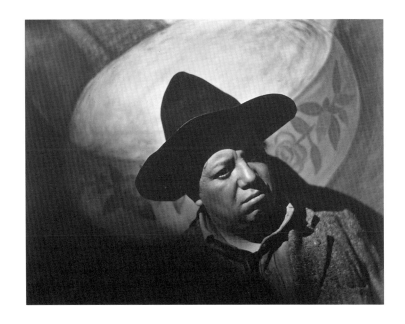

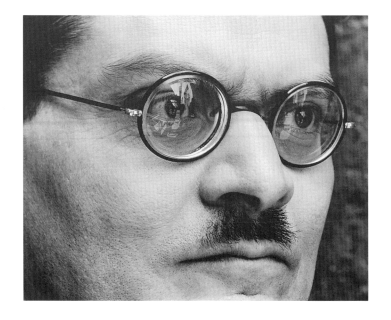

Edward Weston

Diego Rivera, Mexico, 1924

Ansel Adams

José Clemente Orozco, New York City, 1933

Edward Weston

St. Roche Cemetery, New Orleans, 1941

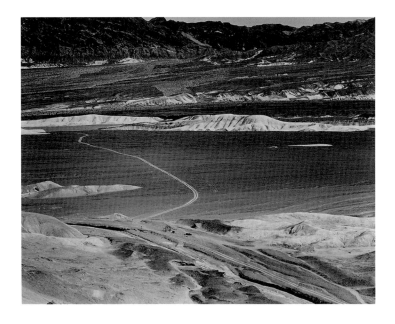

Edward Weston

Twenty Mule Team Canyon, 1938

Edward Weston

Ubehebe Crater Area, Death Valley, 1938

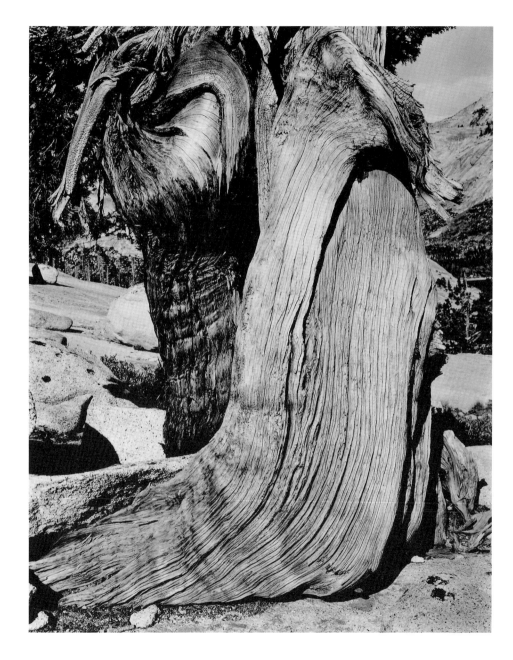

Edward Weston

Juniper, Lake Tenaya, 1937

Edward Weston

Dunes, Death Valley, 1938

Edward Weston

Dead Man, Colorado Desert, 1938

Edward Weston

Pond, Meyer's Ranch, Yosemite, 1940

Edward Weston

Juguetes, Bride and Groom, 1925

Edward Weston

MGM Studios, 1939

Edward Weston

Cyclorama, Twentieth Century Fox, 1940

Edward Weston

Kennebunk, Maine, 1941

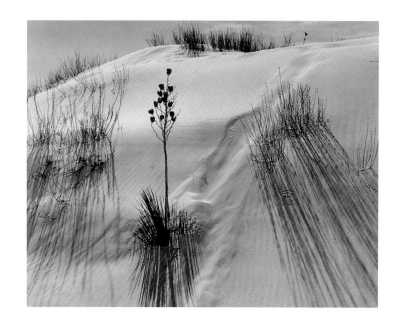

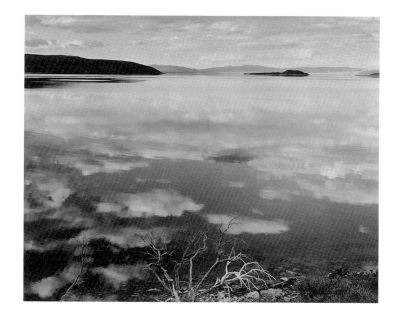

Ansel Adams

Dune, White Sands National Monument, New Mexico, c. 1942

Ansel Adams

Mono Lake, California, c. 1947

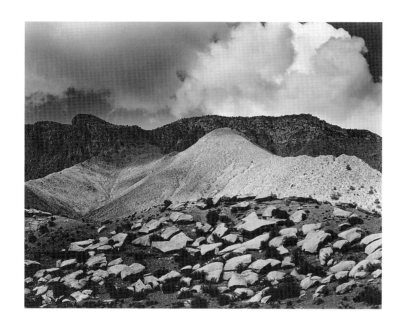

Edward Weston

Cameron, Arizona, 1941

Edward Weston

Lake Hollywood Reservoir, 1936

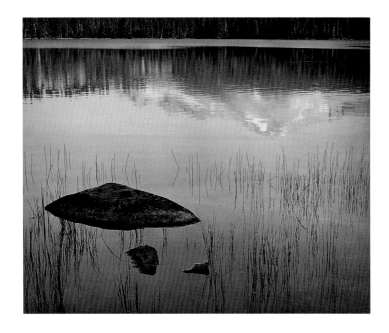

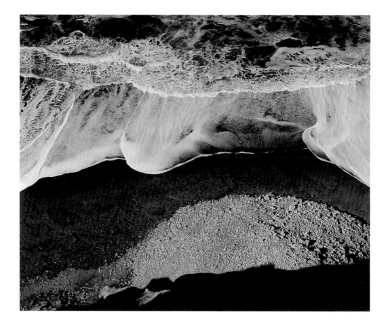

Ansel Adams

Rock and Grass, Moraine Lake, Sequoia National Park, California, c. 1932

Ansel Adams

Surf Sequence #3, San Mateo County Coast, California, 1940

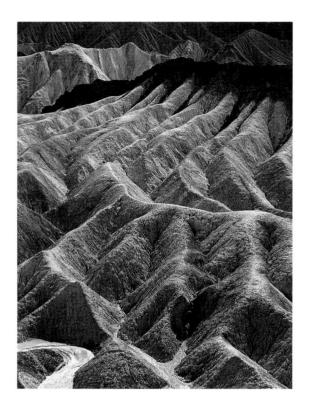

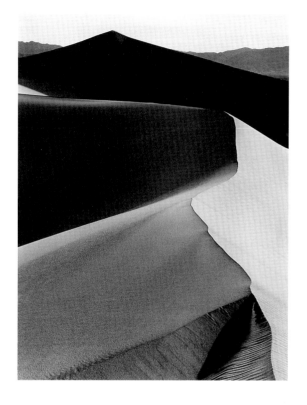

Ansel Adams

Zabriskie Point, Death Valley National Monument, California, c. 1942

Ansel Adams

Sand Dunes, Sunrise, Death Valley National Monument, California, c. 1948

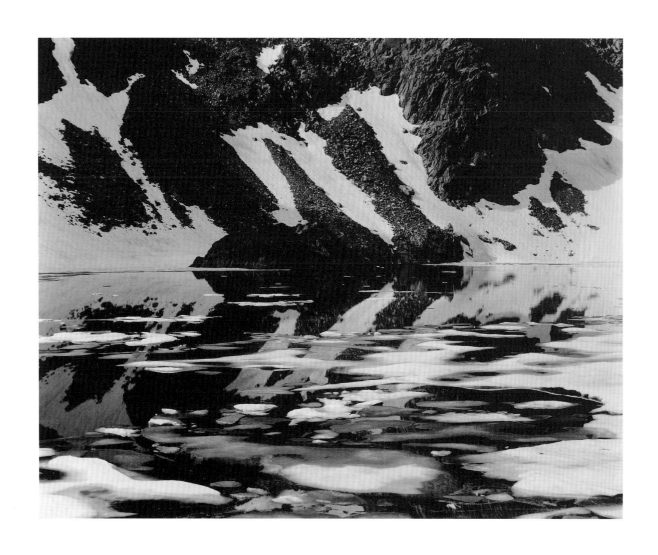

Edward Weston

Iceberg Lake, 1937

Ansel Adams

Canyon de Chelly National Monument, Arizona, 1942

Ansel Adams

The Tetons and the Snake River, Grand Teton National Park, Wyoming, 1942

Ansel Adams

Mormon Temple, Manti, Utah, 1948

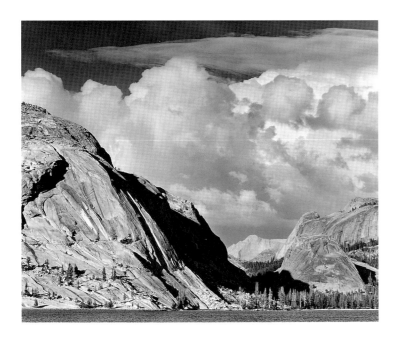

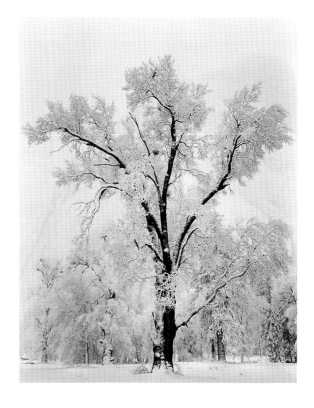

Ansel Adams

Tenaya Lake, Mount Conness, Yosemite National Park, California, c. 1946

Ansel Adams

Oak Tree, Snowstorm, Yosemite National Park, California, 1948

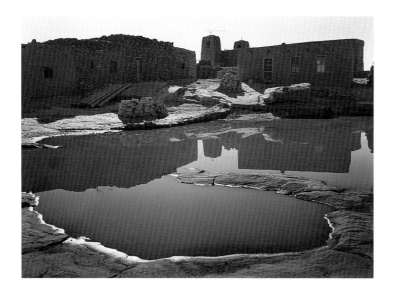

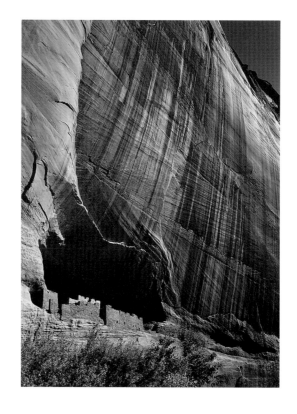

Ansel Adams

Pool, Acoma Pueblo, New Mexico, c. 1942

Ansel Adams

White House Ruin, Canyon de Chelly National Monument, Arizona, 1942

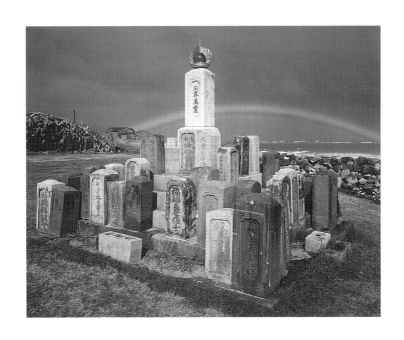

Ansel Adams

*Buddhist Grave Markers and Rainbow, Maui, Hawaii,
c. 1956*

Ansel Adams

Aspens, Northern New Mexico, 1958

Ansel Adams

Cypress and Fog, Pebble Beach, California, 1967

Ansel Adams

Sequoia Gigantea Roots, Yosemite National Park, California, c. 1950

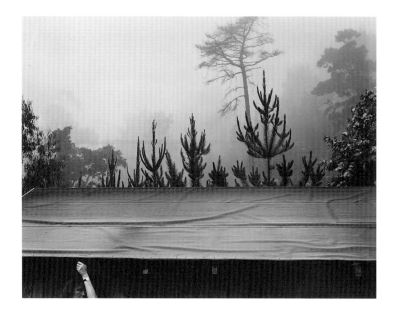

Edward Weston

7 a.m. Pacific War Time, 1945

Ansel Adams

Self Portrait, Monument Valley, Utah, 1958
13 1/4 x 9 1/2 in (34.9 x 24.2 cm)
Ansel Adams Publishing Rights Trust

Artists' Chronologies

Ansel Adams

1902
Born San Francisco, California.

1915
Taken out of school in favor of private tutors.

1916
On a family vacation to Yellowstone National Park began to photograph, using his father's Brownie box camera.

1917
Received a grammar school diploma; worked for two summers in a photofinishing business.

1920
Began to spend summers as Sierra Club custodian at Yosemite.

1925
Decided to become a concert pianist.

1927
Published his initial portfolio; went on his first Sierra Club outing; traveled in California and New Mexico.

1928
First one-man exhibition held; was introduced to Edward Weston; married Virginia Best in Yosemite; son Michael born 1933, daughter Anne born 1935.

1929
Photographed Taos Pueblo for a book project; met Georgia O'Keeffe and John Marin.

1930
After meeting Paul Strand in Taos, gave up music as a profession in favor of committment to a full-time career in photography; built a home and studio in San Francisco.

1932
With Edward Weston and Willard Van Dyke, founded Group f/64.

1933
Met Alfred Stieglitz in New York; opened a gallery in San Francisco.

1937
Moved to Yosemite; fire destroyed his darkroom and 20 percent of his negatives; accompanied Edward Weston on photography trips in the High Sierra; toured the Southwest with Georgia O'Keeffe and David McAlpin; part of the first photography exhibition at the Museum of Modern Art, New York.

1938
Photographed with Edward Weston in Owens Valley.

1941
Systematized the zone system of exposure and development control.

1943
Photographed at Manzanar Relocation Center.

1946
Began to photograph national parks with the first of three Guggenheim fellowships.

1949
Became a consultant for the newly formed Polaroid Corporation.

1950
With Virginia, published Edward Weston's *My Camera on Point Lobos*.

1955
Ansel Adams Yosemite workshop began as an annual event.

1957
Produced unsigned Special Edition prints as Yosemite souvenirs.

1962
Built a home and studio in Carmel Highlands.

1965
Took an active role in President Johnson's environment task force.

1975
Stopped taking individual print orders at the end of the year, but the 3,000 photographs ordered by December 31 took three years to print; helped found the Center for Creative Photography, where his archive is located.

1976
Established an exclusive publishing agreement with the New York Graphic Society.

1979
Increase in print sales led to an expansion of interest in fine art photography collecting; began writing his autobiography.

1980
Received the Presidential Medal of Freedom; transferred his workshop location from Yosemite to Carmel.

1984
Died April 22 of heart failure; Ansel Adams Wilderness Area established near Yosemite; one year later Mount Ansel Adams officially renamed.

Edward Weston

1886
Born Highland Park, Illinois.

1902
Began taking his first photographs (in Chicago parks).

1906
Moved to California; stayed. Decided to become a professional portrait photographer; began by house-to-house canvassing.

1908-1911
Attended Illinois College of Photography; worked as a printer for a commercial portraitist in California.

1909-1919
Married Flora May Chandler; four sons born: Chandler, 1910; Brett, 1911; Neil, 1914; Cole, 1919.

1911
Built and opened a portrait studio in Tropico (now Glendale), California.

1919-1921
Though now a commercial success, became dissatisfied with his own direction; began experimenting with abstract motifs.

1922
Brief journey to Ohio and New York City; photographed steel mills, met Stieglitz, Paul Strand, Charles Sheeler.

1923
Traveled to Mexico with Tina Modotti; opened a portrait studio in Mexico City; was accepted as a vital contributor to the Mexican Renaissance by Rivera, Siqueiros, Orozco, Charlot.

1925
Returned to California for six months; opened a studio in San Francisco with Johan Hagemeyer.

1926
Traveled to Mexico, photographed with Modotti and Brett; returned to California.

1928
Established a studio with Brett in San Francisco; was introduced to Ansel Adams.

1929
Moved to Carmel, California.

1932
With Ansel Adams and Willard Van Dyke, founded Group f/64.

1935
Moved to Santa Monica; opened a studio with Brett.

1937
Awarded the first Guggenheim fellowship for a photographer; traveled through California and the West; accompanied Ansel Adams on photography trips in the High Sierra.

1938
Married Charis Wilson; moved to a house on Wildcat Hill, Carmel, built by his son Neil; photographed with Ansel Adams in Owens Valley.

1941
Traveled through the South and East for a special edition of Whitman's *Leaves of Grass;* trip cut short by attack on Pearl Harbor; served as an air raid spotter at Point Lobos.

1946
Major retrospective at the Museum of Modern Art, New York; monograph published by the museum.

1947
Experimented with color with Willard Van Dyke as a subject while on location for his film *The Photographer.*

1948
Stricken with Parkinson's disease.

1950
Major retrospective in Paris.

1952
Fiftieth Anniversary Portfolio published with Brett's help.

1955
With Brett's help, made eight sets of prints from 830 negatives he considered the best of his life's work.

1956
The film *The World of Edward Weston,* directed by Beaumont and Nancy Newhall, completed and circulated by Smithsonian Institution.

1958
Died New Year's Day, at his home at Wildcat Hill.

Compiled by Susan Kemp, exhibition intern

Bibliography

Ansel Adams

Adams, Ansel. *Ansel Adams: Selected Letters and Images, 1916-1984.* Edited by Mary Street Alinder and Andrea Gray Stillman. Boston: New York Graphic Society, 1988.

————. *Examples: The Making of Forty Photographs.* Boston: New York Graphic Society, 1983.

————. *Images, 1923-1974.* Boston: New York Graphic Society, 1974.

————. *Making a Photograph.* London and New York: The Studio, 1935; 1948. Preface by Edward Weston.

————. *The Portfolios of Ansel Adams.* Boston: New York Graphic Society, 1977. Introduction by John Szarkowski.

Adams, Ansel, with Mary Street Alinder. *Ansel Adams: An Autobiography.* Boston: New York Graphic Society, 1985.

Adams, Ansel, and Mary Austin. *Taos Pueblo,* 1930. Facsimile reprint. Boston: New York Graphic Society, 1977.

Adams, Ansel, with Robert Baker. *The New Ansel Adams Photography Series.* Book I, *The Camera,* 1980; Book 2, *The Negative,* 1981; *Polaroid Land Photography,* 1978; Book 3, *The Print,* 1982; Book 4, *Color Photography,* 1983. Boston: New York Graphic Society.

Alinder, James. *Ansel Adams: 50 Years of Portraits.* Carmel: Friends of Photography, 1978.

Alinder, James, and John Szarkowski. *Ansel Adams: Classic Images.* Boston: Little, Brown and Company, 1985.

Gray, Andrea. *Ansel Adams: An American Place, 1936.* Tucson: Center for Creative Photography, University of Arizona, c. 1952.

Newhall, Nancy. *Ansel Adams: The Eloquent Light.* San Francisco: Sierra Club, 1963; New York: Aperture, 1980.

Edward Weston

Adams, Ansel. "Edward Weston," *Infinity,* February 1964, pp. 16-17, 25-27.

Armitage, Merle, ed. *Fifty Photographs: Edward Weston.* New York: Duell, Sloan and Pearce, 1947.

Bunnell, Peter C. *Edward Weston on Photography.* Salt Lake City: Gibbs M. Smith, 1983.

Bunnell, Peter C., and David Featherstone, eds. *EW100: Centennial Essays in Honor of Edward Weston.* Carmel: Friends of Photography, 1986.

Maddow, Ben. *Edward Weston: Seventy Photographs.* Boston: Little, Brown and Company, 1978.

Newhall, Beaumont. *Supreme Instants: The Photography of Edward Weston.* Boston: Little, Brown and Company, 1986.

Newhall, Beaumont, and Amy Conger, eds. *Edward Weston Omnibus: A Critical Anthology.* Salt Lake City: Gibbs M. Smith, 1984.

Newhall, Nancy. *The Photographs of Edward Weston.* New York: Museum of Modern Art, 1946.

Newhall, Nancy, ed. *Edward Weston: The Flame of Recognition.* Rochester: Aperture, 1965. Reprinted 1971.

Stebbins, Theodore E., Jr. *Weston's Westons: Portraits and Nudes.* Boston: Museum of Fine Arts, Boston, 1989.

Weston, Edward. "Photographic Art." In *Encyclopedia Britannica,* vol. 17. Chicago: Encyclopedia Britannica, 1941, pp. 796-99.

————. *My Camera on Point Lobos.* Edited by Ansel Adams. Yosemite: Virginia Adams; Boston: Houghton Mifflin Co., 1950.

————. *The Daybooks of Edward Weston, vol. I, Mexico; vol. II, California 1927-1934.* Edited by Nancy Newhall. Rochester: George Eastman House, 1961.

Weston, Edward, and Charis Wilson Weston. *California and the West.* New York: Duell, Sloan and Pearce, 1940.

Works in the Exhibition

Ansel Adams

The Ansel Adams photographs in this exhibition, with the exception of *Monolith, the Face of Half Dome, 1927* and *Portrait of Edward Weston, 1945*, constitute the seventy-five images chosen by Adams to make up his Museum Set portfolio. All the works were printed by Mr. Adams.

All works are gelatin silver prints.

Alfred Stieglitz and Painting by Georgia O'Keeffe, An American Place, New York City, 1944 (p. 28)
14 x 11 in (35.5 x 28 cm)

Aspens, Dawn, Dolores River Canyon, Autumn, Colorado, 1937
11 x 14 in (28 x 35.5 cm)

Aspens, Northern New Mexico, 1958 (p. 60)
20 x 16 in (50.8 x 40.6 cm)

Autumn Storm, Los Trampas, Near Penasco, New Mexico, c. 1958
16 x 20 in (40.6 x 50.8 cm)

Barn, Cape Cod, Massachusetts, c. 1937
11 x 14 in (28 x 35.5 cm)

Bridal Veil Fall, Yosemite National Park, California, c. 1927 (p. 35)
20 x 16 in (50.8 x 40.6 cm)

Buddhist Grave Markers and Rainbow, Maui, Hawaii, c. 1956 (p. 59)
16 x 20 in (40.6 x 50.8 cm)

Canyon de Chelly National Monument, Arizona, 1942 (p. 55)
16 x 20 in (40.6 x 50.8 cm)

Church and Road, Bodega, California, c. 1953
20 x 16 in (50.8 x 40.6 cm)

Clearing Storm, Sonoma County Hills, California, 1951
16 x 20 in (40.6 x 50.8 cm)

Clearing Winter Storm, Yosemite National Park, California, 1944
16 x 20 in (40.6 x 50.8 cm)

Cypress and Fog, Pebble Beach, California, 1967 (p. 61)
11 x 14 in (28 x 35.5 cm)

Dawn, Autumn, Great Smoky Mountains National Park, Tennessee, 1948
20 x 16 in (50.8 x 40.6 cm)

Dogwood, Yosemite National Park, California, 1938
14 x 11 in (35.5 x 28 cm)

Dune, White Sands National Monument, New Mexico, c. 1942 (p. 50)
16 x 20 in (40.6 x 50.8 cm)

Eagle Peak and Middle Brother, Winter, Yosemite National Park, California, c. 1968
11 x 14 in (28 x 35.5 cm)

El Capitan Fall, Yosemite National Park, California, c. 1940
11 x 14 in (28 x 35.5 cm)

Evening Clouds and Pool, East Side of the Sierra Nevada from the Owens Valley, California, c. 1962
16 x 20 in (40.6 x 50.8 cm)

Frozen Lake and Cliffs, the Sierra Nevada, Sequoia National Park, California, 1932 (p. 14)
16 x 20 in (40.6 x 50.8 cm)

Georgia O'Keeffe and Orville Cox, Canyon de Chelly National Monument, Arizona, 1937
11 x 14 in (28 x 35.5 cm)

Ghost Ranch Hills, Chama Valley, Northern New Mexico, 1937
16 x 20 in (40.6 x 50.8 cm)

The Golden Gate before the Bridge, San Francisco, California, 1932
16 x 20 in (40.6 x 50.8 cm)

Grand Canyon of the Colorado River, Grand Canyon National Park, Arizona, c. 1942
16 x 20 in (40.6 x 50.8 cm)

Grass and Pool, the Sierra Nevada, California, 1935 (p. 41)
11 x 14 in (28 x 35.5 cm)

Half Dome, Merced River, Winter, Yosemite National Park, California, c. 1938
16 x 20 in (40.6 x 50.8 cm)

High Country Crags and Moon, Sunrise, Kings Canyon National Park, California, c. 1935
11 x 14 in (28 x 35.5 cm)

José Clemente Orozco, New York City, 1933 (p. 42)
11 x 14 in (28 x 35.5 cm)

Juniper Tree Detail, Sequoia National Park, California, c. 1927
14 x 11 in (35.5 x 28 cm)

Leaves, Mount Rainier National Park, Washington, c. 1942
20 x 16 in (50.8 x 40.6 cm)

Lodgepole Pines, Lyell Fork of the Merced River, Yosemite National Park, California, 1921 (p. 24)
11 x 14 in (28 x 35.5 cm)

Manley Beacon, Death Valley National Monument, California, c. 1952
16 x 20 in (40.6 x 50.8 cm)

Merced River, Cliffs, Autumn, Yosemite Valley, California, c. 1939
16 x 20 in (40.6 x 50.8 cm)

Metamorphic Rock and Summer Grass, Foothills, Sierra Nevada, California, 1945
11 x 14 in (28 x 35.5 cm)

Mono Lake, California, c. 1947 (p. 50)
16 x 20 in (40.6 x 50.8 cm)

Monolith, the Face of Half Dome, 1927
53 x 40-1/4 in (134.6 x 102.2 cm)

Monolith, the Face of Half Dome, Yosemite National Park, California, 1927 (p. 35)
20 x 16 in (50.8 x 40.6 cm)

Monument Valley, Arizona, 1958
16 x 20 in (40.6 x 50.8 cm)

Moon and Half Dome, Yosemite National Park, California, 1960
20 x 16 in (50.8 x 40.6 cm)

Moonrise, Hernandez, New Mexico, 1941 (p. 12)
16 x 20 in (40.6 x 50.8 cm)

Mormon Temple, Manti, Utah, 1948 (p. 56)
20 x 16 in (50.8 x 40.6 cm)

Mount McKinley and Wonder Lake, Denali National Park, Alaska, 1947
16 x 20 in (40.6 x 50.8 cm)

Mount Williamson, the Sierra Nevada, from Manzanar, California, 1945 (p. 27)
16 x 20 in (40.6 x 50.8 cm)

Mrs. Gunn on Porch, Independence, California, 1944
16 x 20 in (40.6 x 50.8 cm)

Oak Tree, Rain, Sonoma County, California, c. 1960
16 x 20 in (40.6 x 50.8 cm)

Oak Tree, Snowstorm, Yosemite National Park, California, 1948 (p. 57)
20 x 16 in (50.8 x 40.6 cm)

Old Faithful Geyser, Yellowstone National Park, Wyoming, 1942
20 x 16 in (50.8 x 40.6 cm)

Orchard, Portola Valley, California, c. 1940
16 x 20 in (40.6 x 50.8 cm)

Penitente Morada, Coyote, New Mexico, c. 1950
(p. 29)
16 x 20 in (40.6 x 50.8 cm)

Pool, Acoma Pueblo, New Mexico, c. 1942 (p. 58)
11 x 14 in (28 x 35.5 cm)

Portrait of Edward Weston, 1945 (p. 1)
16 x 20 in (40.6 x 50.8 cm)
Center for Creative Photography

Redwoods, Bull Creek Flat, Northern California, c. 1960
16 x 20 in (40.6 x 50.8 cm)

Rock and Grass, Moraine Lake, Sequoia National Park, California, c. 1932 (p. 52)
16 x 20 in (40.6 x 50.8 cm)

Rose and Driftwood, San Francisco, California, c. 1932
11 x 14 in (28 x 35.5 cm)

Saint Francis Church, Rancho de Taos, New Mexico, c. 1929
16 x 20 in (40.6 x 50.8 cm)

Sand Bar, Rio Grande, Big Bend National Park, Texas, 1947
16 x 20 in (40.6 x 50.8 cm)

Sand Dunes, Oceano, California, c. 1950
20 x 16 in (50.8 x 40.6 cm)

Sand Dunes, Sunrise, Death Valley National Monument, California, c. 1948 (p. 53)
20 x 16 in (50.8 x 40.6 cm)

Sequoia Gigantea Roots, Yosemite National Park, California, c. 1950 (p. 61)
20 x 16 in (50.8 x 40.6 cm)

Siesta Lake, Yosemite National Park, California, c. 1958
16 x 20 in (40.6 x 50.8 cm)

Spanish-American Woman, near Chimayo, New Mexico, 1937
11 x 14 in (28 x 35.5 cm)

Surf Sequence #1, San Mateo County Coast, California, 1940
11 x 14 in (28 x 35.5 cm)

Surf Sequence #2, San Mateo County Coast, California, 1940
11 x 14 in (28 x 35.5 cm)

Surf Sequence #3, San Mateo County Coast, California, 1940 (p. 52)
11 x 14 in (28 x 35.5 cm)

Surf Sequence #4, San Mateo County Coast, California, 1940
11 x 14 in (28 x 35.5 cm)

Surf Sequence #5, San Mateo County Coast, California, 1940
11 x 14 in (28 x 35.5 cm)

Tenaya Creek, Dogwood, Rain, Yosemite National Park, California, c. 1948 (p. 57)
16 x 20 in (40.6 x 50.8 cm)

Tenaya Lake, Mount Conness, Yosemite National Park, California, c. 1946
16 x 20 in (40.6 x 50.8 cm)

The Tetons and the Snake River, Grand Teton National Park, Wyoming, 1942 (p. 55)
16 x 20 in (40.6 x 50.8 cm)

Trailer Camp Children, Richmond, California, 1944
14 x 11 in (35.5 x 28 cm)

Trailside, near Juneau, Alaska, 1947
20 x 16 in (50.8 x 40.6 cm)

Trees, Slide Lake, Grand Teton National Park, Wyoming, c. 1965
11 x 14 in (28 x 35.5 cm)

Vernal Fall, Yosemite Valley, California, c. 1948
20 x 16 in (50.8 x 40.6 cm)

White House Ruin, Canyon de Chelly National Monument, Arizona, 1942 (p. 58)
20 x 16 in (50.8 x 40.6 cm)

White Mountain Range, Thunderclouds, from the Buttermilk Country, near Bishop, California, c. 1962
16 x 20 in (40.6 x 50.8 cm)

Winnowing Grain, Taos Pueblo, New Mexico, c. 1929
14 x 11 in (35.5 x 28 cm)

Winter Sunrise, the Sierra Nevada, from Lone Pine, California, 1944 (p. 6)
16 x 20 in (40.6 x 50.8 cm)

Zabriskie Point, Death Valley National Monument, California, c. 1942 (p. 53)
20 x 16 in (50.8 x 40.6 cm)

Edward Weston

The Edward Weston photographs in this exhibition are from the "project prints" that were printed from negatives selected by Weston in 1953. Due to the failing health of the artist, 830 images were actually produced (from a goal of 1,000). The works were printed by the artist's son, Brett, also a photographer, under the supervision of Edward Weston.

All works are gelatin silver prints.

Almond Orchard, Clear Lake, 1939
8 x 10 in (20.3 x 25.4 cm)
CR-CL-5g

Ansel Adams, 1943 (p. 1)
8 x 10 in (20.3 x 25.4 cm)
PO43-A-1

Arizona Nymph, 1938
7 3/8 x 9 1/2 in (18.8 x 24.2 cm)
A-Mi-1g

Badwater, 1938
8 x 10 in (20.3 x 25.4 cm)
DV-Mi-24g

Boat and Cove, 1938
8 x 10 in (20.3 x 25.4 cm)
PL-L-16g

Boat-builder (Neil), 1935
10 x 8 in (25.4 x 20.3 cm)
40 M

Boat with Abalone Shells, 1938
8 x 10 in (20.3 x 25.4 cm)
PL-R-14g

Boulder Dam, 1941
8 x 10 in (20.3 x 25.4 cm)
N41-BD-3

Brett, 1942
8 x 10 in (20.3 x 25.4 cm)
PO42-B-1

Burned Car, Mojave Desert, 1937 (p. 41)
10 x 8 in (25.4 x 20.3 cm)
MD-HSS-13g

Cacti, 1932
10 x 8 in (25.4 x 20.3 cm)
14 C

Cameron, Arizona, 1941 (p. 51)
8 x 10 in (20.3 x 25.4 cm)
A41-CC-1

Carlos Merida, 1934
5 x 4 in (12.7 x 10.1 cm)
307-PO

Carmelita Maracci, 1937
5 x 4 in (12.7 x 10.1 cm)
305-PO

Casa de Vecindad, D.F, 1926
8 x 10 in (20.3 x 25.4 cm)
5 Mi

Cement Worker's Glove, 1936 (p. 40)
7 5/8 x 9 1/2 in (19.4 x 24.2 cm)
28 Mi

Chard, 1927
10 x 8 in (25.4 x 20.3 cm)
1 V

Charis Weston, 1935 (p. 16)
5 x 4 in (12.7 x 10.1 cm)
310-PO

Clouds, Death Valley, 1939
8 x 10 in (20.3 x 25.4 cm)
DV-39c-25g

Colorado Desert, 1938
8 x 10 in (20.3 x 25.4 cm)
CD-Mi-5g

Cyclorama, Twentieth Century Fox, 1940 (p. 49)
8 x 10 in (20.3 x 25.4 cm)
LA40-20c-9

Cypress Root, Pebble Beach, 1929
10 x 8 in (25.4 x 20.3 cm)
23 T

Dante's View, Death Valley, 1938
8 x 10 in (20.3 x 25.4 cm)
DV-DV-1g

Dead Bird, 1938
8 x 10 in (20.3 x 25.4 cm)
PL-R-2g

Dead Man, Colorado Desert, 1938 (p. 46)
8 x 10 in (20.3 x 25.4 cm)
CD-B-2g

Death Valley, 1939
8 x 10 in (20.3 x 25.4 cm)
DV-39c-3g

Death Valley, 1939
8 x 10 in (20.3 x 25.4 cm)
DV-39c-5g

Deserted Landing, Big Sur Coast, 1932
8 x 10 in (20.3 x 25.4 cm)
19 L

Diego Rivera, Mexico, 1924 (p. 42)
7 1/2 x 9 1/4 in (19.1 x 23.5 cm)
5 PO

Dunes, Death Valley, 1938 (p. 46)
8 x 10 in (20.3 x 25.4 cm)
DV-D-6g

Dunes, Death Valley, 1938
8 x 10 in (20.3 x 25.4 cm)
DV-D-18g

Dunes, Oceano, 1936
8 x 10 in (20.3 x 25.4 cm)
37 SO

Elsa, 1945
8 x 10 in (20.3 x 25.4 cm)
PO45-E-1

Erica, Point Lobos, 1947
8 x 10 in (20.3 x 25.4 cm)
PL47-ER-1

Fence, Old Road, Big Sur, 1935
7 1/2 x 9 1/2 in (19.1 x 24.2 cm)
46 L

Guadalupe Marin de Rivera, Mexico, 1924
(p. 17)
8 1/8 x 7 in (20.6 x 17.8 cm)
8 PO

Iceberg Lake, 1937 (p. 54)
8 x 10 in (20.3 x 25.4 cm)
E-IL-4g

Jerome, Arizona, 1938
8 x 10 in (20.3 x 25.4 cm)
A-J-2g

Johan, 1925
8 x 10 in (20.3 x 25.4 cm)
56 PO

Juguetes, Bride and Groom, 1925 (p. 48)
10 x 8 in (25.4 x 20.3 cm)
17 J

Juguetes, Cherubim, 1926
10 x 8 in (25.4 x 20.3 cm)
41 J

Juguetes, Palma Bendita, 1926
10 x 8 in (25.4 x 20.3 cm)
3 J

Juniper, Lake Tenaya, 1937 (p. 45)
9 3/8 x 7 3/8 in (23.8 x 18.8 cm)
J3-2g

Juniper, Tenaya, 1937
10 x 8 in (25.4 x 20.3 cm)
J1-c-1g

Kelp, 1930
8 x 10 in (20.3 x 25.4 cm)
10 K

Kennebunk, Maine, 1941 (p. 49)
8 x 10 in (20.3 x 25.4 cm)
ME41-K-1

Lake Hollywood Reservoir, 1936 (p. 51)
8 x 10 in (20.3 x 25.4 cm)
48 L

Lake Tenaya Country, 1940
8 x 10 in (20.3 x 25.4 cm)
Y40-T-3

La Teresina, 1933
4 x 5 in (10.1 x 12.7 cm)
312-PO

Leadfield, 1939 (p. 32)
10 x 8 in (25.4 x 20.3 cm)
DV-L-4g

Lighthouse at Point Sur, 1940
8 x 10 in (20.3 x 25.4 cm)
SSH40-S-3

Manley's Trail, Golden Canyon, 1938
8 x 10 in (20.3 x 25.4 cm)
DV-GC-13g

Meraux Plantation House, Louisiana, 1941
10 x 8 in (25.4 x 20.3 cm)
L41-PH-13

MGM Studios, 1939
8 x 10 in (20.3 x 25.4 cm)
LA-MGM-12g

MGM Studios, 1939
8 x 10 in (20.3 x 25.4 cm)
LA-MGM-13g

MGM Studios, 1939 (p. 31)
8 x 10 in (20.3 x 25.4 cm)
LA-MGM-16g

MGM Studios, 1939 (p. 48)
10 x 8 in (25.4 x 20.3 cm)
LA-MGM-22g

Monument on Wilshire Blvd, 1936
9 9/16 x 7 1/2 in (24.3 x 19.1 cm)
29 Mi

Moonstone Beach, 1937
8 x 10 in (20.3 x 25.4 cm)
NC-MB-16g

New Mexico, 1941
8 x 10 in (20.3 x 25.4 cm)
NM41-CH-1

Nude, 1923 (p. 37)
8 x 10 in (20.3 x 25.4 cm)
19 N

Nude, 1924
8 x 10 in (20.3 x 25.4 cm)
34 N

Nude, 1927 (p. 36)
10 x 8 in (25.4 x 20.3 cm)
64 N

Nude, 1934
4 x 5 in (10.1 x 12.7 cm)
137 N

Nude, 1934
5 x 4 in (12. 7 x 10.1 cm)
142 N

Nude, 1934 (p. 8)
3 1/2 x 4 1/2 in (8.9 x 11.4 cm)
145 N

Nude, 1934 (p. 36)
5 x 4 in (12.7 x 10.1 cm)
150 N

Nude, 1934
4 x 5 in (10.1 x 12.7 cm)
161 N

Nude, 1934 (p. 16)
5 x 4 in (12.7 x 10.1 cm)
192 N

Nude, 1939 (p. 38)
8 x 10 in (20.3 x 25.4 cm)
N39-M-6

Nude, New Mexico, 1937
8 x 10 in (20.3 x 25.4 cm)
NM-A-N2g

Nude, New York City, 1941
9 5/8 x 7 9/16 in (24.4 x 19.2 cm)
NY41-24W55-1

Oceano, 1936 (p. 20)
8 x 10 in (20.3 x 25.4 cm)
47 SO

Oceano, 1936
8 x 10 in (20.3 x 25.4 cm)
55 SO

Oceano, 1936
8 x 10 in (20.3 x 25.4 cm)
56 SO

Pepper, 1929
10 x 8 in (25.4 x 20.3 cm)
14 P

Pepper, 1930
8 x 10 in (20.3 x 25.4 cm)
31 P

Pepper, 1930 (p. 19)
10 x 8 in (25.4 x 20.3 cm)
34 P

Point Lobos, 1930 (p. 38)
9 3/8 x 7 1/2 in (23.8 x 19.1 cm)
57 R

Point Lobos, 1930 (p. 26)
8 x 10 in (20.3 x 25.4 cm)
62 R

Point Lobos, 1932
8 x 10 in (20.3 x 25.4 cm)
39 R

Point Lobos, 1944
8 x 10 in (20.3 x 25.4 cm)
PL44-L-2

Point Lobos, 1946
10 x 8 in (25.4 x 20.3 cm)
PL46-L-4

Pond, Meyer's Ranch, Yosemite, 1940 (p. 47)
8 x 10 in (20.3 x 25.4 cm)
Y40-MR-8

Pulqueria, Mexico City, 1926
10 x 8 in (25.4 x 20.3 cm)
57 A

Pulqueria Painting, Mexico, 1926 (p. 31)
8 x 10 in (20.3 x 25.4 cm)
33 Mi

Pump, Tacubaya, Mexico, 1924
10 x 8 in (25.4 x 20.3 cm)
8 Mi

Red Rock Canyon, 1937
10 x 8 in (25.4 x 20.3 cm)
RRC-1g

Rhyolite, Nevada, 1938
8 x 10 in (20.3 x 25.4 cm)
DV-R-1g

Root, Rocks, Cliffs, Lake Tenaya, 1937
7 1/2 x 9 1/2 in (19.1 x 24.2 cm)
T-L-3g

Saguaro, 1938
8 x 10 in (20.3 x 25.4 cm)
A-S-9g

St. Roche Cemetery, New Orleans, 1941
(p. 43)
10 x 8 in (25.4 x 20.3 cm)
L41-NOC-6

Salton Sea, 1938
8 x 10 in (20.3 x 25.4 cm)
CD-Mi-1g

San Carlos Lake, Arizona, 1938
8 x 10 in (20.3 x 25.4 cm)
A-CD-10g

Sand Erosion, Oceano, 1934 (p. 39)
10 x 8 in (25.4 x 20.3 cm)
16 SO

7 a.m. Pacific War Time, 1945 (p. 62)
7 1/2 x 9 1/2 in (19.1 x 24.2 cm)
C45-FOG-1

Shoe, Moonstone Beach, 1937
8 x 10 in (20.3 x 25.4 cm)
NC-MB-4g

Sperm Whale's Teeth, 1931 (p. 15)
10 x 8 in (25.4 x 20.3 cm)
13B

Surf, Bodega, 1937
8 x 10 in (20.3 x 25.4 cm)
NC-BC-9g

Surf, Orick, 1937 (p. 27)
8 x 10 in (20.3 x 25.4 cm)
NC-O-2g

Taliesin West, 1941
8 x 10 in (20.3 x 25.4 cm)
A41-TW-1

Taos, New Mexico, 1937
8 x 10 in (20.3 x 25.4 cm)
NM-T-4g

Taos Pueblo, New Mexico, 1933
8 x 10 in (20.3 x 25.4 cm)
41 A

Tomato Field, 1937
8 x 10 in (20.3 x 25.4 cm)
SC-BS-1g

Tracks in Sand, 1937
8 x 10 in (20.3 x 25.4 cm)
NC-LR-3g

Twenty Mule Team Canyon, 1938
7 7/16 x 9 1/2 in (18.9 x 24.2 cm)
DV-TME-2g

Twenty Mule Team Canyon Entrance, 1938
(p. 44)
8 x 10 in (20.3 x 25.4 cm)
DV-TME-7g

Ubehebe Crater Area, Death Valley, 1938 (p. 44)
7 1/2 x 9 1/2 in (19.1 x 24.2 cm)
DV-U-10g

Vulture, Mojave Desert, 1937
8 x 10 in (20.3 x 25.4 cm)
MD-V-1g

White Radish, 1933
10 x 8 in (25.4 x 20.3 cm)
58 V

William Edmundson, Sculptor, Tennessee, 1941
8 x 10 in (20.3 x 25.4 cm)
T41-ED-1

Winter Zero's Bottle Farm, Ohio, 1941
8 x 10 in (20.3 x 25.4 cm)
041-WZ-8

Yaqui Church, Arizona, 1941
8 x 10 in (20.3 x 25.4 cm)
A41-Y-2

Yosemite Mists, 1938
8 x 10 in (20.3 x 25.4 cm)
YS-C-2g

Zabriskie Point, 1938
8 x 10 in (20.3 x 25.4 cm)
DV-Z-9g

Type set in Helvetica
Typography by Thomas & Kennedy, Seattle
Printed by Rono Graphic Communications on
Karma Text and Cover.